BACK ON THE FIRE

Other Books by Gary Snyder

BACK ON THE FIRE

THE FIRE

E · S · S · A · Y · S

GARY SNYDER

SHOEMAKER & HOARD

Library of Congress Cataloging-in-Publication Data

Snyder, Gary, 1930–
Back on the fire : essays / Gary Snyder.
p. cm.
ISBN-13: 978-1-59376-137-0
ISBN-10: 1-59376-137-6
I. Title.

PS3569.N88B33 2007
814'.54—dc22

2006030689

Book design by Gopa & Ted2, Inc.
Printed in the United States of America

Shoemaker 𝕊𝕙 Hoard
www.shoemakerhoard.com

10 9 8 7 6 5 4 3 2

Dedicated to Jack Shoemaker

Advisor, Critic, Student, Teacher, Comrade

"Heart set on the Way,
strong in *virtu*,
grounded with humanity,
roaming through the arts"

Lun Yü (Analects) VII.6

Contents

■ ■ ■

PART ONE

1.

Fires, Floods, and Following the Dao

■ ■ ■

WITH ALL the television scenes of trees flaming out in the big western wildfires over the last few years, fire has become part of the national conversation. It has also, unfortunately, become one more excuse for higher levels of commercial logging.

For Californians, the prevalence of fire has been another lesson in the true nature of our bioregion. California has a predictable summer drought and a high-risk fire season absolutely every year. That's what is called a summer-dry Mediterranean-type climate, and California in this regard is unlike any place else in the western hemisphere except parts of coastal Chile.

Most California families have only been here a few years at most since World War II. Very few are clued in to the winter-wet summer-dry phenomenon. This whole West Coastal slope has plant species that are uniquely adapted to the combination of wet roots in winter and long drouth in summer. This gives us large, vigorous, thriving forests that are also at great risk for fire over the dry season. In fact some of the species are fire-adapted and don't reproduce until after a fire. The ecological health of our forests is in part dependent on periodic low-level fires.

I don't think in terms of "California," though—I think "West Coast"; my childhood was around Puget Sound. As a ten-year-old coming down from western Washington to California to see the World's Fair in San Francisco, I was immediately suspicious of the golden-brown

dry grass slopes and hills that look like warm sexy animal bodies, the absence of a solid forest on the hills, the smell of eucalyptus, and the places with Spanish names. Also the broad space of the great Central Valley, though you get a small taste of that in the Willamette Valley of Oregon. And then (though we had Chinatowns in Seattle and Portland) to see the Grant Street Chinatown, San Francisco, was a revelation. Live fish in tanks, duck eggs, Chinese characters everywhere.

Adjusting to the California climate will lead to an appreciation of California native plants. Fanatics like me belong to the California Native Plant Society and read its journal, *Fremontia*, cover to cover. I take up the causes of quitting all-summer-green watered lawns, and the renunciation of Atlantic Coast high-water-usage landscaping. There are at least a dozen California native plant nurseries now, and landscape architects who specialize in their use. We also need to look for a more fitting architecture. The California-Hispanic or Mission-derived architecture of so many fine little houses built during the 1920s and 30s is a great direction to revisit. The campus of Saint Mary's College near Moraga is an example, as is most of the architecture at Stanford.

Hispanic occupation stopped just north of the San Francisco Bay. The Petaluma adobe is the most northerly example. A Mexican boat went up the Sacramento to the mouth of the Feather, but that's about it. Northern California is still a different country. Until World War II there was a movement in northern California—a trace of it still remains—that hoped to create a fourth West Coast state of "Jefferson": it would have included some of southern Oregon. The movement for Jefferson was cut off by the war, but it lingers on in things like the name of the public radio station out of Southern Oregon State University at Ashland, which calls itself "Jefferson Public Radio." Others have simply started calling northern California and a bit of southern Oregon "Shasta." In this thinking, "Shasta" extends all the way down to Monterey Bay. Then there is a "natural nation" of middle California, and yet another natural nation south of the Tehachapis and including part of Baja. The northern California of tan grass, a few oaks, and

Douglas fir on the ridges continues well into southern Oregon. Ponderosa pine is found scattered along the Five almost to Canyon City, Oregon. The Rogue River valley is in the same gardening zone (seven in the *Sunset Western Garden Book*) as the foothills of Nevada and Placer County. Ponderosa pine is the most widely distributed conifer in the West and grows well into Mexico at the higher elevations. In the Sierra Nevada middle-elevation zone along those east–west running ridges and canyons, the south slope vegetation puts you in Mexico, and the north slope vegetation takes you to Oregon. Manzanita is found on northern Cortez Island in the Straits of Georgia, British Columbia. I saw some up there with my own eyes. And I never drive over Donner Pass without, just cresting the summit, saying to myself, "Aha, the Great Basin." That is a bioregional boundary—and where the Truckee River heads on out to rest in Pyramid Lake. Whatever California really is, it fades away when you cross the Sierra crest and get those vanilla- or caramel-smelling Jeffrey pines.

Back to the human. One of my father's cousins, from Seattle, visited San Francisco every few years on business, and he could never get over saying (this was forty years ago), "And I saw some queers! They have homosexuals right on the street there." It wasn't that he was outraged; he was just baffled.

When I was a boy, west-side Washington-state people seemed to be either Lutherans or Socialists. We were just speculating recently (at a dinner in Clarksville, Tennessee, the home of Fort Campbell and the 101st Airborne) about how New Orleans is developing more and more into an alternative culture city like San Francisco. It was suggested that maybe that's because they are both Catholic, and the Catholics got used to tolerating weirdness for so many centuries—after they gave up on the inquisition as a hopeless task—and that makes a better habitat for dissenters. At least in the western hemisphere. For a long time I was the youngest straight poet in the North Beach circle of gay poets. They were always very tolerant of my heterosexuality, though once when asked "Why don't you even try it?" (meaning gay sexuality), I found myself saying, "I don't think I'd be very good at it."

My first perceptions of "difference" between the Northwest and California, as I have been indicating, had to do with plants, smells, climates, and landscapes. And views. Living in San Francisco was a new kind of difference for me—I was a laborer on the docks—and able to afford an inexpensive apartment on Telegraph Hill on an entry-level wage. I shared the apartment with fellow ex-Oregonian poet Philip Whalen—both of us relishing the Italian and Chinese groceries possible within a few blocks of our apartment—learning to cook new things—smoking Balkan Sobranie Turkish cigarettes every Sunday (what a treat)—the Basque Hotel up near Broadway with carafes of wine on the table and a fixed-price meal that was more than you could eat. On weekends we had the happily blasted, multi-gender, multi-sexual parties that for a while had no dope at all (that came a few years later), just red wine. The Frenchness, Catholicness, the East Asian connections of San Francisco delighted me. I said once that living in San Francisco made it unnecessary to go to Europe, at least for a young man from a stump farm in northern Washington.

For a spell I lived in Berkeley and was a graduate student in classical Chinese and in Japanese at the big U. For two years I spent every Saturday methodically browsing the Indo-Tibetan and East Asian section of the stacks. The Berkeley Buddhist Church with its evening study group meetings, hosted by the lovely Jane Imamura, wife of the priest, was for me the friendliest place in town. Kenneth Rexroth once wrote a poem on a 1940s political conversation he had late at night in "Sam Wo's" juk [rice-gruel] restaurant just above Grant Street in Chinatown. It does not belong to someone named Sam (as all the North Beach poets thought). The characters "Sam Wo" mean "Three Harmonies." It stayed open until 3:00 A.M., and it was still there in February of 2003. Such are the benefits, to borrow a phrase from Kenneth, of a Classical Education.

In accord with the differences of their bioregional landscapes, the cultures are different. Northern California was settled by Swiss-Italians, Portuguese, French, Italians, people from the Azores, and some Hispanics. A Mediterranean population for a Mediterranean climate. The Japanese found a way to make the Central Valley, old waterfowl

wetlands, into giant rice fields. Most of the lowland rice-growing in China came after the conversion of waterfowl wetlands three thousand years ago.

The Pacific Northwest had Finns, Swedes, Norwegians, Germans, and New Englanders. People who liked rain, dark trees, and wooden buildings. For years there was a hardcore Anarchist newspaper in Finnish that was published in Astoria at the mouth of the Columbia. The Petaluma area was host to a huge egg industry for many decades, and many of the chicken farmers were Jewish Anarchists. My sister, Thea Lowry, wrote a book on Petaluma chicken-farming and its radical ranchers called *Empty Shells.*

Red Emmerson is the founder of the towering and mysterious forest products company, Sierra Pacific Industries. His father, Raleigh, whose nickname was "Curly" and who had started with a cow-pasture saw-mill, was an honorary manager of the great company for many years, a sign of his son's generous and respectful filial piety. Curly liked to stay at the Chancellor Hotel whenever he came to San Francisco. My son Gen and I stayed in the Chancellor Hotel seven or eight years ago for several nights and went dining in old Italian restaurants in North Beach. We had a ceremonial Campari cocktail in Gino and Carlos Bar on Green Street in honor of Jack Spicer. The Chancellor is a very reasonable old hotel, right near Union Square.

Once I had arrived in Japan (by freighter in 1956) it was instantly clear to me that the climate and landscape was not at all like the Pacific Northwest. It is much more like Virginia or North Carolina. When I settled in the Yuba River country of the Sierra Nevada thirty-four years ago I was able to adapt fairly easily because I had already worked as a logger in the open forests of east side Oregon on the Warm Springs Indian Reservation, and I was at home with ponderosa pine and man-zanita. Still, it took me some years—while developing a farmstead and raising a family—to cop to the fact that we had better be seriously prepared for the fire that would come. Finally we got serious about fire-breaks and underbrush removal at our place and put in a pond and a little pump, lots of fire hose, backpack pumps, and a couple of nomex jackets. How come it took me so long? Because I had long maintained

an irrational faith in the California Division of Forestry and its fire-fighting air tankers. I assumed that they could stop any fire from the air in short order. Now it's back to self-reliance for the long term, back to sustainability. Do not place too much faith in government.

And that takes me again to my first topic, which was fire. California is under the sign of fire: but also under the sign of flood. A great Sierra-wide fire will come, and so will the flood that will make the Great Central Valley into a lake again, as it was during one winter in Sutter's time, when everything from mountain lions to rattlesnakes retreated up into the Sutter Buttes. Flood and fire are perfectly natural. And earthquakes are too. East Coast critics of California like to pretend that we have no stress or danger here, and that that makes us shallow and hedonistic. But in California everyone has some *natural* disaster to prepare for. These things are beyond left or right, good or evil. Since everything is impermanent anyway, we can say our looming fires, floods, and earthquakes give a kind of impartial stability to our life. Natural disasters are what some folks call "acts of God." I wish we could say the same for our changing administrations, and the fecklessness of the leaders we seem to elect. Whatever else you can say, California—so despised by certain factions in America—is a place of considerable freedom. Oddly enough, even as the current administration proposes to spread it abroad, this is the very commodity that is suppressed at home.

The experts have been telling us that the best way to prevent forest fires is to start lots of little fires each year to reduce the underbrush, and the best way to prevent great floods is to take down the levees and let the water gently wander. In ancient China this would have been approvingly described as "Following the Dao."

2.

The Ark of the Sierra

■ ■ ■

I'M A longtime forest and mountain person of the West Coast. I grew up on a farm outside Seattle, my father and uncles all worked at various times in logging and fishing, and I started off helping my dad on one end of a two-man saw when I was about eleven. I've worked in the woods from the Canadian border down to Yosemite. I've fought fire, built trails, planted trees, done seasons on lookouts, been a timber-scaler and a choker-setter. And I've considered myself a conservationist since I was seventeen—when I first wrote to Congress in regard to an issue in the Olympic National Forest.

I'm concerned primarily with two things: our new understanding of the ecological role of fire, and something bigger that goes with that, the possibility of a truly sustainable forestry in the Sierra. When I was a self-righteous youth in my twenties I thought that my jobs as fire lookout and firefighter gave me a real moral advantage—I told my city friends, "Look, when I do this kind of work I can really say I'm doing no harm in the world, and am only doing good." Such ironies. Now I get to join in the chorus that says it was all wrong-headed, even if well-intentioned (almost as wrong as when I climbed to the summit of Mount Saint Helens up in Washington at age fifteen and announced "this beautiful mountain will long outlast the cities." Now the mountain is half gone, and the cities are doing fine).

This North Central Sierra area, especially here on the west side, is not quite as charismatic and scenic as the southern Sierra. We have no Yosemite Valley or Kings River Canyon, but we do have exquisite

little high country lakes and many meadows rich in summer flowers, high white granite ridges and crisp, bright snowfields. In the mid-elevations we have some of the finest pine forest in the world. The lower foothills are manzanita fields with extensive oak grasslands that have been changing, during the last two decades, from cattle ranches to ranchettes.

In the watersheds of the American, Feather, and Yuba River systems are some of the loveliest streams in California, offering top quality trout fishing. The oak and brush lands are major migratory songbird nesting territory—I know because my wife, Carole was out early at least one morning every week last spring mist-net-trapping, banding, and collecting sex and age data on the little things. Deer and wild turkeys grace the front yards of people all across the foothills. My wife and I and many of our friends are among those who welcome back the bears and cougars, even while recognizing the risk. We didn't move up here to live the soft, safe, and easy life, and we love having these hairy scary neighbors. We will try to figure out how to be safe and smart even though they're around. One can always buckle on a bear-attack pepper spray canister when going for a lone jaunt. And speaking of lone jaunts, John Muir's famous adventure—that he wrote about in *The Mountains of California* of climbing high up into a sugar pine during a severe windstorm—took place a few ridges over, probably near the town of Challenge.

Our North Central Sierra shares its geological and biological history with the rest of the Greater Sierran ecosystem. There are paleo-Indian sites in this county that indicate human presence from eight thousand years ago. The "pre-contact" forest was apparently a mosaic of various different forest stages, from brush fields to many broad and open ancient-forest stands. Spring and fall, salmon ran up all the rivers. Deer, salmon, waterfowl from the valley, and black oak acorns were the basis of a large and economically comfortable native population, a people who made some of the most skillful and beautiful baskets in the world.

The Yankee newcomers initially came to look for gold. They needed lumber and thought, as newcomers did everywhere else in North

America, that the forest was limitless. One can see early photographs taken around the foothill towns, and the hills are denuded. It's a tribute to the resilience of the local forest that, where allowed to, it has come back quite well.

So early on there was the vigorous mining industry and extensive logging. Later much of the mountain land was declared public domain, and it came to be the responsibility of the U.S. Forest Service (USFS) and the Bureau of Land Management. The USFS from the twenties up until the seventies was a confident and paternalistic organization that thought it always knew best, and for a while maybe it did. During those years it was generally trusted by both the conservation movement and the timber industry. In any case, from the 1950s on there was a lot of heavy industrial logging in the public and private lands of the Sierra.

With the seventies came a renewed rise of environmental concern. Part of that consciousness was connected maybe to better biology education in the schools and a general growth of interest in nature. Curious people got out in the mountains by pickup, on foot, or by bike, and sometimes studied the areas that had been logged. People could see that old-growth habitat was drastically shrinking. We all knew that some species were being lost or endangered (the wolf and grizzly already gone, probably the wolverine) and there were rumors that the national forest logging was sometimes subsidized at an actual financial loss to the taxpayers. The public became aware, as never before, of its stake in the Sierra Nevada.

So we entered an era of reevaluation and reconsideration of past policies. The USFS unfortunately lost much of the respect of the conservation community, and it also got hammered by the timber industry. For a while it looked like the Forest Service couldn't win, *whatever* it did. There *have* been some highly contested issues. For conservationists, extensive clear-cutting became symbolic of how the federal land managers seemed to be hostage to the timber economy; and the spotted owl became symbolic to the timber industry of hated environmental regulations, and money-losing issues involving critters that almost nobody has ever seen. The owl itself is a hapless and innocent bird that never meant to cause so much trouble. The gold

rush era left many worthy legacies in this land; it also left some people with a sort of "use it up" attitude. Those who arrived in the seventies and after may have been quick to love nature, but they seemed to have little concern for the economy.

During the hearings that led to the establishment of Redwood National Park on the north coast, a sawmill operator testified, "Why, nobody ever goes in those woods but hippies and their naked girl-friends." Well, some of those girls went on to college and became lawyers.

These wrangles have led some of us to try and figure out where the different parties, those able and willing to argue with sincerity and in good faith, might find areas of agreement. The fairly recent realization that the Sierra Nevada is a fire-adapted ecosystem, and that a certain amount of wildfire has historically been necessary to its health, has given everyone at least one area within which they can agree. Another area of potential agreement is the growing awareness that we will sooner or later have to manage long-range sustainable forestry. In fact, the two absolutely go together. If we don't reduce the fuel load, the really big fires that will inevitably come will make good forestry a moot point. But it will take a little more than new fire poli-cies to achieve good forestry.

I was on a panel in San Francisco several years ago with Jerry Franklin, the eminent forest scientist now based at the University of Washington. So last month I took it on myself to write him the fol-lowing question:

Dear Jerry,

I would like to be able to say that "Long range sustainable forestry practices—such as will support full biodiversity—and be relatively fire-resistant—and also be on some scale economically viable—lasting over centuries—is fully possible. And what we must now do is search out and implement the management program that will do that." Do you think I can say this & that the science will support it?

Jerry Franklin immediately wrote me back:

> What you propose is totally and absolutely feasible for the Sierra Nevada, i.e., long-term sustainability, full biological diversity, relative fire resistance (low probability of catastrophic crown fire), and economic viability. A system which provides for restoration and maintenance of a large diameter tree component (with its derived large snags and down logs) and which provides for moderate to high levels of harvest in the small and medium diameter classes (allowing escapement of enough trees into the large diameter class to provide replacements for mortality in the large diameter group) and prescribed burning in some locations can do this. Other considerations include riparian protection and, perhaps, shaded fuel breaks. Economic and sustainable in perpetuity!

So it's theoretically possible. But science can only suggest—such a marvelous sustainable forestry cannot actually happen unless the culture itself chooses that path. "The culture" means not only the national public but also the working people of the very region where the resource policy decisions are made. It will take local people working together with local land managers to make the serious changes in public lands policies that we need. Just a quarter of a century ago, the idea of active local engagement with public land decision-making would have been thought pretty utopian.

One of the reasons we might trust the people of the Sierra to provide valuable input has to do with how much the local people have learned on their own. In the twenty-five years I've lived in this part of the Sierra we have seen a growing contribution of knowledge from a multitude of fine amateur naturalists. Just here in Nevada County we have seen the formation of a California Native Plant Society chapter, the local production of a hiking guide to the region, a locally written and published bird species checklist, a fine botany of a high country lake region by a person of the area, a similar low-elevation wildflower guide, and detailed forest inventories done by volunteers on San Juan Ridge. There's a sophisticated, locally based research project on

pileated woodpecker behavior, family life, and reproduction going on right now. Extensive research has been done on the stream systems and main rivers of the Yuba by another set of volunteers. And many of us are in personal debt to the esteemed Lillian Mott for her generous help in identifying mushrooms.

Also the forestry and biology experts of the Tahoe National Forest, the B.L.M., and our colleges and universities have been generous in sharing their time and expertise with ordinary citizens. Timber operators have visited at least one school I know of, Grizzly Hill, and allowed children to come and observe a logging show. There are a number of significant new organizations in the North Central Sierra. Many are focused on ecological issues, and some are concerned with access to resources. They all have a stake in the health of the Greater Sierran Ecosystem. This process of newcomers becoming a "people of the place," which started in 1849, has been progressing at variable speeds ever since, and has surged ahead in the last two decades.

For new fire and forestry practices to really become national public policy, they must be *local* public choices first.

We locals can help bring this to reality by getting involved with the Bureau of Land Management and USFS in further community forestry projects, in working toward innovative value-added wood-products industries, and in supporting cooperative fire management projects. If we can clarify and express our own choices, our congresspersons just might represent us, and federal policies might begin to reflect local desires. Agencies might facilitate this process by being a lot more willing to take risks with the public than they've been so far, putting more of their people out in the field where they can meet folks, and looking for opportunities to break out and try things with locals.

There has always been fire. The catfaces on the oaks, the multiple stems sprouting from certain old oak centers, and the black cedar stumps that seem to be timeless made it clear to me that there had been a sizeable fire through our land some years back. A neighbor, now passed on, told me of a big burn some sixty years ago. But our local forest has recovered well. This Sierra ecosystem has been fire-adapted for millions of years, and fire can be our ally. The growing recognition

of this fact—with the public and with the fire agencies—has been a remarkable change to watch develop during the past ten years. In my own neighborhood a small prescribed burn was done this spring with considerable success. And we have also been trying out the mechanical crunching of brushfields—expensive, but it works.

One word of caution, however. As our enthusiasm for prescribed burns and more sophisticated fire management grows, we need to remember for a moment the fire ideologies and bureaucracies of the past. Steve Pyne, in his book *World Fire*, traces the history of the American wildfire-fighting establishment and the way it demonized fire as an enemy. He points out how the language of forest firefighting for years ran parallel to the language of the Cold War—clearly militaristic, and speaking of forest fires as though they were Godless Communist armies. Firefighting requires organization, courage, and tremendous energy and dedication, to be sure. But we are called now to a more complex moral attitude, where we see fire as an ally in the forest, even while recognizing its power to do damage.

The understanding of fire—its hazards, its use as a tool, and the way it shapes a fire-adapted forest—should help keep our different factions working together. We may disagree as to how important the survival of some species might be or how many acres of land should reasonably be converted to suburbs or what the annual allowed timber cut ought to be, but we surely will agree that we're against tall flames burning timber and houses, and that we should work together for a "fire management" that sees fire as a partner in the ecosystem, not an enemy. This may be a tentative step toward new and more amicable relations between the conservationists, who want to go slow and be careful, and the resource users, who have their businesses to run.

There's another hard fact here that I haven't yet mentioned. It may in the long run be the most important factor of all. The whole west side of the Sierra (the entire *West*) is experiencing an amazing rate of housing growth, which brings suburban homes right up against wildlife habitat, public forests or mineralized zones, a zoning term meaning "areas under which significant mineral resources are known to lie, hence zoned so that mining might still be permitted at some

point." These developments may be in conflict with both loggers and environmentalists. Public lands will become all the more precious to us, as ranches and farms give way to development.

Our public lands are lands held in trust for all of us. A certain responsibility goes with that, for the government, for the public at large, and for the people of the region. As for stewardship, or trust, we can see that the whole world is in the trust of humans now, whether we want this responsibility or not. The air and waters, the rivers, the deer and owls, the genetic health of all life are in our trust. We are here discussing Biodiversity—a word that sends shivers of alarm through some hearts—but it only means variety of life, and it means "Right to Life for Nonhuman Others," a moral sentiment I religiously support. If God hadn't wanted all these critters to be around, including rattlesnakes and cougars, he wouldn't have put them on the Ark. The high country and the forests are the twenty-first century Ark of the Sierra, an Ark even for all of California. Let's be sure it's an ark that stays afloat. Let's not try to second-guess God.

Grass Valley/Nevada City, 6.VI.96

3.

Migration/Immigration

*Wandering South and North, Erasing Borders,
Coming to Live on Turtle Island*

MIGRATION. The simple matter of people moving from one place to another, maybe from one bioregion to another. In the old days sometimes peaceful, even harmless.

But immigration—now that's political! It means you're crossing the boundaries of this or that nation-state, with the hope of staying. Any discussion of immigration must by definition assume the nation-state system, with the socio-political mindset that usually ignores the non-human communities and ecological boundaries of the "country."

There are those who argue that since the majority of the North American population is descended from immigrants it would be somehow wrong to change past policies and try to slow immigration down or even bring it to a halt. This backward-looking position fails to see that, although people do move to new places, they can be expected in time to become members of that place and to think in terms of the welfare of the place itself. People who have moved do not remain immigrants, with "old country" nostalgia, forever—when our loyalties are to the land we live on, the debate changes.

The liberal thinkers who defend further immigration into the United States in the name of compassion, tolerance, and diversity—or even in the name of the economy—might often be the same people who sympathize with the injustices that Native Americans suffered through the last half-millennium on account of us reckless newcomers. They might also count themselves as environmentalists. We need

to look at how the question of immigration fits with an environmental conscience and with the call for ecological as well as social justice.

The key idea is "carrying capacity." Seeing as how a big non–Native American population is actually here, we must address the question of how all of us can live together, without endless guilt, and with ecological wisdom for the long run. So it's time for Americans to grow up and BE here. Once having done so, they will become competent to consider the essential questions of both carrying capacity and economic sustainability. "Carrying capacity" is a working concept that tries to understand what the limits to growth of a given species in a given region might be, allowing the other inhabitants to also flourish. Looking at the needs of diverse forests and soils and the cycles of water and air, the evidence suggests that North America is already over-populated by humans. Some will say that all we need to do is consume fewer resources per person and distribute the wealth: then a smaller population won't be necessary. That might in some cases be true. But what the heck, why not shrink the human population and truly leave space for the other critters? The criteria for human carrying capacity must include genuine diversity of species in their needed large wild habitat. Not just as tokenism. Quality over quantity.

Sometimes new immigrants might be welcomed. So the same kind thinking must be extended to them: that they not just "share in the American Dream" but share in the challenge of living wisely for the long run on Turtle Island.

The question of immigrants from Mexico into the States is complex. Remember the Treaty of Guadalupe Hidalgo? It promised the Californios and the Indians that they would retain title to all their lands. Alta California was shaped by Hispanic culture—as far north as Petaluma and Sonoma—for over two centuries. The Mexican people, our North American brothers and sisters, carry a big percentage of Native American blood. They are an old vernacular population with a powerful culture. They push north because of poverty. There must be other ways to approach this problem. If we wish to slow down the flow of people looking for better lives, we must work on the question of the Mexican economy, looking for ways to help make life within Mexico

less bleak. NAFTA is obviously no reliable answer. Expose American corporations that corrupt Mexican workers. Help Mexico transform! The United States and Mexico might someday be true partners—what a wonderful idea.

But why not try the bioregional approach and declare the boundaries between the United States and Mexico, the United States and Canada, null and void. Natural regions, and their capacities, would be the touchstone. A bunch of gringos could move south if they had the will to learn. Let the Chicanos who want to move north and give their work and loyalty to the Cascades or the Great Basin. (The Arctic Inuit already have a hemi-circumpolar nation of their own.) All of us together will limit population growth, white and brown alike, and then learn our ecosystems—together—from Panama north—in Spanish, English, and Navajo, and Lakota. Multiracial patriots / matriots / of Turtle Island.

Offshore immigrants—new ones from Asia, Africa, Europe—when allowed, will be called on to learn not just U.S. history and the Constitution, but the landscapes, watersheds, plants, and animals of their new home. Maybe someday that would include long walks in the desert, or meditations by Appalachian waterfalls, as part of their initiation into the work of the new world. Each person will come back out of the sweat-lodge purified, reborn, no longer an immigrant, but a person whose work and heart are here in North America.

Of course, first, we self-satisfied citizens of the United States must do this for ourselves. We all need to become people who are responsible to the land, and only then can we ask as much of anyone else who might hope to live here.

4.

Ecology, Literature, and the New World Disorder

■ ■ *Gathered on Okinawa* ■ ■

THE MAIN island of the Ryukyu chain, Okinawa, is an old cultural crossroads. There is a long history of trade in goods and songs with Taiwan and Korea, and a record of highly respectful formal relations with mainland China still well remembered in Okinawa. In prehistoric times Pacific and Southeast Asian coastal cultural influences met and mingled with influences that came across from the Korean peninsula. This is where the oceanic and the continental cultures have long met and where the northern and the southern parts of East Asia came together.

Naha, the largest city on Okinawa and the old capital of the Ryukyu Kingdom, is rich in craft and art. The inscription on the sign at the big gate to Shuri Castle says in Chinese characters, "A Nation That Preserves Ceremony"—which I understand in its ancient spiritual meaning of "good manners toward the whole world."

Old Okinawa had a society that became famous for its hospitality, its music (especially the songs and melodies of the *sanshin*, the Okinawan prototype to the *shamisen*), its dance, its cheerful hardiness, and its self-sufficiency in art and culture. In recent decades in the aftermath of World War II, the Ryukyus have sometimes absorbed influence from the United States. The presence of the huge military

Based on a keynote talk given at the Association for the Study of Literature and the Environment international conference held in Naha, Okinawa, in the Ryukyu Archipelago, March 4–6, 2003.

airbase has been very difficult for the island—but many Okinawans also feel that Hawai'ian and mainland American cultural movements have had creative and broadening effects on the ongoing culture.

The whole Ryukyu chain is a place of natural and cultural distinction. Ocean currents, volcanoes, Pacific storms, deep sea orcas, flying fish, and wheeling birds. Here's a salute to the spirits of rice and sweet potato, and as always, the Goddess of Dance and Song.

THIS NEW WORLD DISORDER

We all know that the "post–Cold War" era has suddenly and rudely ended, and we have entered a period in which global relations are defined by new nationalisms, religious fundamentalism, developed world hubris, stepped-up environmental damage, and everywhere expanding problems of health and poverty. What was to have been a "New World Order" is revealed as a greater disorder, much of it flowing from the top down.

Disorder is nothing new in the human world. East Asia, the Indian subcontinent, the Middle East, and Europe have all gone through cycle after cycle of violent change—oppression at home, exploitation abroad, and bloody warfare. Much of it has been driven by various combinations of fanatic ideological beliefs, whipped-up nationalisms, and institutionalized greed. The great civilizations have had moments of peace and marvelous cultural and artistic accomplishments, punctuated by eruptions of hysteria, outbreaks of violence, and war after war after war.

The destruction of the World Trade Towers and the sudden loss of thousands of lives are, realistically, not a historical anomaly. Famines, plagues, huge fires, earthquakes, eruptions, and warfare are registered all through history. There was never a time when a little wisdom, patience, and reflection wouldn't serve to improve decision-making in times of emergency.

The Bush administration that was and is in power in the United States has little sense of history and no patience. With the war on Iraq, we have all been drawn into what Jonathan Schell calls "An American

Tragedy." The shredding of international trust, the deceptions practiced on the people of the United States and Britain, and the unresolved chaos in the lives of Iraqis, Israelis, and Palestinians make this a worldwide tragedy.

But perhaps we could focus on considering the natural world as regarded by human society, the natural world as it is found in the literary and other arts. In most of the world now the outlook for the natural environment is not good. Initially the Bush administration's retreat from environmental priorities was presented as being simply "pro business." The aftermath of September 11, 2001, then enabled the Bush/Rumsfeld/Cheney forces to cloak their anti-environmentalism in the rhetoric of patriotism. There are corporations and government agencies that enthusiastically welcome this. The post 9/11 world of research universities is also changing directions. My own school, the University of California at Davis, quickly developed plans to build a "biocontainment laboratory" to study deadly viruses and bacteria, clearly a response to the rise of terrorist fears.

In the Modern Language departments, there are probably Eurocentric scholars who always thought that the new interest in "nature literature" was just a shallow trend and who have begun to hope that things like the recent emergence of eco-criticism, or the study of "the environmental imagination," or concerns for "environmental ethics," "nature literacy," and "the practice of the wild" will now pack up and head back to the hills. But it won't happen.

A huge number of contemporary people realize that we can no longer think that the fate of humanity and that of the nonhuman natural world are independent of each other. A society that treats its natural surroundings in a harsh and exploitative way will do the same to "other" people. Nature and human ethics are not unconnected. The growing expansion of ecological consciousness translates into a deeper understanding of interconnectedness in both nature and history, and we have developed a far more sophisticated grasp of cause and effect relationships. The lively discipline of environmental history is constantly enlarging how we understand both nature and culture. Politically there is a constituency for environmental causes in every nation.

Every one of the world religions has examined its own relation to the environment and is hoping to improve it. In a number of societies, a reverence and care for nature has been deep in the culture from the beginning. In the case of Japan we can see how a long-established love of nature can wither in the face of extreme urbanization and aggressive economic expansion. The grassroots public of Japan, however, has a resilient spirit for the defense of nature.

In literature—in North America certainly—nature was long seen as a marginal subject area, with ties to writings of adventure and travel, and mixed into eccentric solitary musings, trappers' journals, farm wife diaries, cowboy and logger narratives, and quasi-religious pantheistic landscape enthusiasms.

However, over the last forty years a body of fresh creative work has been written that remakes the field. A small number of critics and scholars have responded to this with admirable energy, and we are in the midst of the emergence of a distinguished territory of literature that calls for further analysis and for expanded teaching. I am thinking of people who came after Rachel Carson and Aldo Leopold to develop a new form of literary/ecological theory. Consider the critical and social insights in the writings of Tom Lyon, Sherman Paul, John Elder, Stephanie Mills, Lawrence Buell, Cheryl Glotfelty, David Abrams, Scott Slovic, and, most recently, Jed Rasula. Or the creative nonfiction and "natural history" writings of Gary Paul Nabhan, Peter Matthiessen, David Rains Wallace, David Quammen, Douglas Chadwick, Rick Bass, Barry Lopez, Richard Nelson. Then there is the towering oeuvre of John McPhee, who writes out of the magic of sheer information and lately has begun to create a prehuman geological mythos for North America. And I'm not even mentioning the recent advances in the ecological and earth sciences, or the committed and engaging research and writings of environmental activist writers and groups, with their contribution to shaping public policy and a growth of grassroots American connections with the land.

What we refer to as nature or the "environment" or the wild world is our endangered habitat and home, and we are its problem species. Living in it well with each other and with all the other beings is our

ancient challenge. In this time of New World Disorder, we need to find the trick of weaving civilized culture and wild nature into the fabric of the future. This will take both art and science. We can take heart, however, from the fact that the actual physical world sets conditions that are some of the strongest guards against ignorant extremism and fanaticism. "Get real! Get a life!" is the daily message of Mother Nature.

Stay the course, my friends.

THE OPENING OF THE FIELD

A poem of this title by Robert Duncan concludes with the lines

> Often I am permitted to return to a meadow
> as if it were a given property of the mind
> that certain bounds hold against chaos

In our field of literature and the environment, we are permitted to return to this meadow, this forest, this desert, as a given property of the deeply natural human mind. Here are the bounds that—in ways too complex for us to grasp—hold against chaos. Remember that chaos is a human invention.

The English word "nature" is from Latin *natura*, "birth, constitution, character, course of things"—initially from *nasci*, to be born. It connects with the root *nat*, which is connected with birth, so we have nation, natal, and native. The Chinese word for nature is *zi-ran* (in Japanese *shizen*), meaning "self-thus." The English word "nature" is commonly used in its practical science sense, referring to the material universe and its rules. In other words, nature means "everything" except perhaps the "supernatural." The rural and the urban are part of the phenomenal world natural.

Wild nature is that part of the physical world that is largely free of human agency. Wild nature is most endangered by human greed or carelessness. "Wild" is a valuable word. It refers to the process or

condition of nature on its own, without human intervention. It is a process, a condition, not a place. "The wilds" is a place where wild process dominates.

The word "environment" is functionally equivalent to the term "nature." In English the environment is that which "surrounds"—from the Old French *viron*, encircle. In Japanese the term *kankyo* has much the same set of meanings. The weight of feeling between "nature" and "environment," though, is different. We can relate instantly to a "nature lover," while an "environment lover" sounds slightly odd and clumsy. But the latter term is useful, because it highlights the point that all entities are members of each other's environment. I am part of your surroundings just as you part of mine. This sort of mutuality is acknowledged in Buddhist philosophy and highly developed in ecological thought.

Before writing was invented there were many literary traditions that flourished entirely in the oral mode. These oral literary traditions, some of which are still alive, contain oceans of stories and huge numbers of riddles, proverbs, myths, rhythmic epic narratives, secular songs, and religious chants. Many deal in great depth with the natural world, and yet they may seem unlike what we might think of as "nature writing" today. They are never distanced from their subject matter. They clearly reflect the bioregion of the society, whether arid lands or moist tropical jungle, and they do not speak of nature in the abstract. They often reflect the mode of subsistence and so may be largely agrarian in their interests, or they might be engaged with hunting and gathering and explore interactions with a wide range of animals. They offer an acute observation of and a deep sense of identification with the nonhuman. The line between the life of the fields and that of the village is not hard and fast. In any case wilderness, in the sense of being the most inaccessible part of a given territory, is seen as a shared space that is both dangerous and magical, a place to visit for spiritual and economic reasons. The body of lore that we are all heir to is constantly enlarging.

Economy and ecology, two key terms, both have the Greek *oikos* as their main root, with the simple meaning of "household." Economics

is "rules of the household," and ecology referred originally to the study of biological and metabolic systems. The term literally means something like "household studies." More recently it took on additional meanings, something like "love of and virtuous behavior in regard to nature."

I have already mentioned the "new world disorder." And what is order? The whole phenomenal world, and the mathematics that might be said to underlie it, are all creatively and freely orderly. Art, architecture, philosophy, and agriculture are, from the human standpoint, models of orderliness. There is much that humans find disorderly, but "wild nature" is the ultimate source of order. In the nonhuman universe, not a single leaf that falls from a tree is ever out of place.

EAST ASIA TEACHES US ALL

The remarkably coherent and persistent cultures of East Asia have yielded a literature (in Japan, Korea, Taiwan, and China) that is unmatched in the matter of representing nature in art and writing.

Art and song everywhere begins in folk culture: celebration, dance, music, story, song, poem. In a way the greatest of the original five Chinese classics is the fifth century B.C. *Shih Ching* (Shikyo in Japanese), the "Book of Songs." It is, for East Asian poetry, the "mother of poems." It is also, possibly, the "mother of Confucius." It has its roots clearly in a folk song tradition that is easily a thousand years older than the written text. Is it about nature? Not exactly. This is poetry of an agrarian society, so there are few "wild landscapes." There are many poems of people going about their daily life in nature, working in the fields and orchards, loving and courting, and occasionally celebrating and feasting. Many plants are named, wild and domestic. East Asian civilizations have never made the sharp separation between the human and the rest of biological nature that is formalized in the "the religions of Abraham"—Judaism, Christianity, and Islam. This Abrahamic dichotomy persists in contemporary monotheisms and is severely with us yet today. Most educated Occidental people who profess to be secularists are still often in thrall to such dualism. In East Asia,

from earliest folk religion through Daoism and Confucian teachings, and on into the practices and philosophy of Mahayana Buddhism and its coexistence with surviving folk Shinto in Japan, humans have been seen as part of nature. In all the high schools of Japan, Korea, China, Taiwan, and Vietnam, they teach Darwinian evolution as the model of biological being on earth. They are amazed that school boards in the United States might try to ban this.

Paradoxically, because East Asians so easily feel a part of nature, it has been assumed that whatever humans did was perfectly natural—not a bad assumption in its way—and so deforestation and extinction of species in earlier centuries did not usually alarm people. It was just nature beating up on nature, like elephants I saw smashing and ripping the twigs and limbs off mopane trees, their favorite food, in the forests of Botswana.

The songs of the *Shih Ching* are benign, practical, innocent, and sweet. The founding anthology of Japanese poetry, the *Manyoshu*, has a morning-of-the-world feeling, too. There is love and loneliness, and there are long solitary travels through what were wild landscapes in the early Heian era, the wild grassy fields and reed marshes of lowlands that had not yet been converted to farming. These grassland and wetland poems disappear from later Japanese poetry—the changes in a landscape reflected in poems over centuries could be a study in itself.

Hsieh Ling-yun (Setsu Reiun in Japanese) (385–433 A.D.) is considered the first self-conscious Chinese poet of larger landscapes. He was a bold mountain explorer in the steep hills of south China. He also wrote a very long prose poem on the matter of dwelling in the mountains. English speakers are indebted to the Australian scholar J. D. Frodsham for making these lyric poems available in translation. From the T'ang dynasty onward some of China's finest poets were writing lyrics of nature. David Hinton compiled an anthology of English translations of what he calls "Chinese wilderness poems" that was published as *Mountain Home* (Counterpoint Press, 2002). It contains poems by Wang Wei (Oi), Tu Fu (Toho), Li Po (Rihaku), Po Chu-i (known as Hakurakuten in Japan), Su Shih (Soshi), and many others.

These are the prime Chinese poets, and they don't really qualify as "wilderness poets." The Chinese themselves would call some of them "field and garden" poets. I like the term "mind/nature poets," because the "mind/nature" axis reaches deeply into the interior wildness, and so these poets deserve our great regard. Most of these Chinese writers are well known in Korea and Japan, and some have had a profound influence. In Chinese prose writings there are also remarkable travel journals, geographical and geological essays, land-use surveys, and many other sorts of works that deserve closer attention.

The Japanese haiku is truly a "nature tradition" but a sharply focused one. The vocabulary of the seasons and the symbolic implications of different plants is codified—social construction meets poetic landscape! There are thousands of insightful and precious little poems in the tradition. In spite of the haiku's limits, it helps people pay attention to botany, the many facets of the seasons, and countless other tiny details of the natural daily world.*

The Korean poet Ko Un, though very much a contemporary, is also a kind of bridge from the ancient *Book of Songs* (through his knowledge of both Chinese literature and Korean folk song) into twentieth-century modernism, mixed with a strong influence of Zen practice. The poems in his English-language book *The Sound of My Waves* are richly human, often village-based, funny and sweet. Another English-language collection, *Beyond Self* (with an astute foreword by Allen Ginsberg), should be called Zen poems, and they are better than most poems called such, because of their genuine inventiveness and gritty joy. Ko Un is another "mind/nature" poet.

Many of the best-known East Asian poets were touched by, or even deeply engaged with, the teachings of the Zen or Ch'an or Son (Korean) school of Buddhism. A sly Zen influence can be seen everywhere in East Asian art. In terms of environmentalism, the Buddhist ethical teaching that we should "avoid harm to all beings" as far as reasonably possible,

* Haruo Shimane's *Traces of Dreams: Landscape, Cultural Memory, and the Poetry of Basho* (Stanford, 1998) provides fascinating new details as to the daily social and economic lives of the haiku poets and their interactions with each other.

which is the Buddhist teaching of *ahimsa* or nonharming/nonviolence or *fusessho*, has had a profound effect. It is not always an easy precept to follow, especially for a modern industrial nation with a developing economy. East Asian industries and expansion have severely damaged the environment, including forests of the Third World countries in recent years.

We study the great writings of the Asian past so that we might surpass them today. We hope to create a deeply grounded contemporary literature of nature that celebrates the wonder of our natural world, that draws on and makes beauty of the incredibly rich knowledge gained from science, and that confronts the terrible damage being done today in the name of progress and the world economy.

Ecological Imperatives

"Nature" and "environment" are words that basically refer to "that which is." As such, they are bland terms—colorless, or a light shade of green. (The color of the environment could just as well be blood red, or sap-amber, or sky blue.) Nature, and environment, as terms, feel like "places." "Ecology" is a term, like "wild," for *process.*

"Ecology" refers to a dynamic always in flux. It moves us away from the old sense of the world as something created in time that might now be running down and getting worn; away from the idea of the world as a clock or a machine or a computer, to a "world as process," a creation happening constantly in each moment. A close term in East Asian philosophy is the word *Dao*, the Way, *dô* in Japanese.

When we come to the field of ecology we are looking at population dynamics, plant and animal succession, predator–prey relationships, competition and cooperation, feeding levels, food chains, whole ecosystems, and the flow of energy through ecosystems—and this is just the beginning. In my work on western American forest issues over the last few years, I have learned a great deal from forest ecology, with the help of my older son Kai Snyder, who is a professional in the field. Forest ecology calculates the constant dynamism of natural systems, the continuous role of disturbance, and the unremitting effects of climatic fluctuations.

What sort of poem or story can draw from the inner energy of an ecosystem? If this "literature of the environment" were parallel to the history of fiction, I'd say we have now reached the point where we're tired of stock figures and charming plots, and we want to get into the inner lives and psyches of our characters, all their obsessions, kinkiness, and secrets. We will necessarily be exploring the dark side of nature—nocturnal, parasitic energies of decomposition and their human parallels. Also, the term "ecology," which includes energy exchange and interconnection, can be metaphorically extended to other realms. We speak of "the ecology of the imagination" or even of language, with justification: "ecology" is a valuable shorthand term for complexity in motion.

I've enjoyed and learned a lot from Jed Rasula's *This Compost: Ecological Imperatives in American Poetry* (University of Georgia Press, 2002). It picks up from Lawrence Buell's brilliantly learned and instructive book *The Environmental Imagination* (Harvard, 1995) and penetrates the territory of both ecology and the adventurous side of contemporary poetics. Rasula does so without needless nature piety, getting right down to the metaphors of decay and fertility, mulch and nutrition, as singularly critical to language and art—and demonstrates this in Walt Whitman's poem "This Compost," in Emily Dickinson, in George Santayana, and in Thoreau, who wrote in his *Journals*, "Decayed literature makes the richest of all soils." Rasula's forays into Ezra Pound, Charles Olson and the Black Mountain poets, the Beats (in particular Michael McClure), Rothenberg's ethnopoetics, Clayton Eshleman's Deep History, Paul Shepard's "coming home to the Pleistocene," and Gregory Bateson's *Steps to an Ecology of Mind* are supplemented by my own thinking as in "Poetry, Community, and Climax." I will quote a section from it here:

Detritus cycle energy is liberated by fungi and lots of insects. I would then suggest: as climax forest is to biome, and fungus is to the recycling of energy, so "enlightened mind" is to daily ego mind, and Art to the recycling of neglected inner potential. When we deepen

ourselves, looking within, understanding ourselves, we come closer
to being like a mature ecosystem. Turning away from grazing on
the "immediate biomass" of perception, sensation, and thrill; and
reviewing memory . . . blocks of stored inner energies, the flux
of dreams, the detritus of day-to-day consciousness, liberates the
energy of our own mind-compost. Art is an assimilator of unfelt
experience, perception, sensation, and memory for the whole soci-
ety. It comes not as a flower, but—to complete the metaphor—as a
mushroom: the fruiting body of the buried threads of mycelia that
run widely through the soil, intricately married to the root hairs of
all the trees. "Fruiting"—at that point—is the completion of the
work of the poet, and the point where the artist reenters the cycle:
gives what she or he has re-created through reflection, returning a
"thought of enlightenment" to community.

Human history, with its languages and migrations, is like an old
forest floor of detritus, old and new mingled together, old resent-
ments recycled, ancient recipes rediscovered, and perennial mytholo-
gies strutting shamelessly on the stage of the moment. The "ecological
imperative" must be that we try to see whatever current crisis we are in
as part of an older larger pattern. But it also is an imperative to honor
diversity, whether of species or of languages and customs.

Scholarship continually spades and turns the deep compost of lan-
guage and memory; and creative writing does much the same but add-
ing more imagination, direct experience, and the ineluctable "present
moment" as well. Our work as writers and scholars is not just "about"
the environment, not just "speaking for" nature, but manifesting in
ourselves and our work the integrity of the wild. The complexity of
a working metropolis, with its energy, sewage treatment, transpor-
tation, public auditoriums, parks, water, and solid waste systems, is
rather like a climax ecosystem. Making these links into song and story
is work for an artist—a chance for somebody to write some great
super-urban haiku.

PERFORMANCE IS CURRENCY

The name of the peerless traditional Japanese theater called Noh, one of the world's greatest art forms, means "accomplishment." Zeami, the founder of Noh, wrote dozens of essays on what it took to be accomplished: background learning and reading, attention and much attendance at the performances of others, and practice, practice, practice. Further, he suggests the almost-magical capacity to go beyond years of practice into selfless freedom again. The ability to surprise yourself even years later. Poets and artists who are dedicated to their craft know the importance of skill. And there is one more point: Who is this flower for?

A Zen verse says,

> The moon shines on the river,
> The wind blows through the pines—
> Who is this long, beautiful evening for?
> (from the *Cheng Dao Ke*)

Outwardly the Noh plays were for the dedicated aristocrats and warrior-administrators who supported the arts. Inwardly they are for the tender, deep, mind-hearts of everyone.

One time in Alaska a young woman asked me, "If we have made such good use of animals, eating them, singing about them, drawing them, riding them, and dreaming about them, what do they get back from us?" An excellent question, directly on the point of etiquette and propriety, and from the animals' side. I told her, "The Ainu say that the deer, salmon, and bear like our music and are fascinated by our languages. So we sing to the fish or the game, speak words to them, say grace. We do ceremonies and rituals. Performance is currency in the deep world's gift economy." I went on to say I felt that nonhuman nature is basically well inclined toward humanity and only wishes modern people were more reciprocal, not so bloody. The animals are drawn to us, they see us as good musicians, and they think we have cute ears.

The human contribution to the planetary ecology might be our entertaining craziness, our skills as musicians and performers, our awe-inspiring dignity as ritualists and solemn ceremonialists—because that is what seems to delight the watching wild world.

The critic and writer Ronald Grimes took up this aspect of my curious line of thought—he is a performer himself—and developed it into an actual performance that he called "Performance Is Currency in the Deep World's Gift Economy: An Incantatory Riff for a Global Medicine Show" (the text of it was published in *Isle* 9: 1 [Winter 2002]). Grimes's background as teacher, performer, and student of religion gave him outstanding insight into what I had thrown out as a Mahayanistic intuition and gave it solid footing.

The "deep world" is of course the thousand-million-year-old world of rock, soil, water, air, and all living beings, all acting through their roles. "Currency" is what you pay your debt with. We all receive, every day, the gifts of the Deep World, from the air we breathe to the food we eat. How do we repay that gift? Performance. A song for your supper.

Gift economy? That might be another perspective on the meaning of ecology. We are living in the midst of a great potluck at which we are all the invited guests. And we are also eventually the meal. The Ainu, when they had venison for dinner, sang songs aloud to the deer spirits who were hanging about waiting for the performance. The deer visit human beings so that they might hear some songs. In Buddhist spiritual ecology, the first thing to give up is your ego. The ancient Vedic philosophers said that the gods like sacrifices, but of all sacrifices that which they most appreciate is your ego. This critical little point is the foundation of yogic and Buddhist *askesis*. Dôgen famously said, "We study the self to forget the self. When you forget the self you become one with the ten thousand things." (There is only one offering that is greater than the ego, and that is "enlightenment" itself.)

The being who has offered up her enlightenment is called a Bodhisattva. In some of the Polynesian societies the Big Person, the most respected and powerful figure in the village, was the one who had nothing—whatever gift came to him or her was promptly given away again. This is the real heart of a gift economy, an economy that would

save, not devour, the world. Gandhi once said, "For greed, all of nature is insufficient." Art takes nothing from the world; it is a gift and an exchange. It leaves the world nourished. The arts, learning grandmotherly wisdom, and practicing a heart of compassion, will confound markets, rattle empires, and open us up to the actually existing human and nonhuman world. *Performance* is art in motion, in the moment, enactment and embodiment: which is exactly what nature herself is.

> "Ripples on the surface of the water—
> were silver salmon passing under—different
> from the ripples caused by breezes"

> A scudding plume on the wave—
> a humpback whale is
> breaking out in air up
> gulping herring
> —Nature not a book, but a *performance,* a
> high old culture

> Ever-fresh events
> scraped out, rubbed out, and used, used, again—
> the braided channels of the rivers
> hidden under fields of grass—

> The vast wild
> the house, alone.
> The little house in the wild,
> the wild in the house.
> Both forgotten.

> No nature

> Both together, one big empty house.

5.

Thinking Toward
the Thousand-Year Forest Plan

■ ■ ■

Frederick Law Olmsted wrote to his wife from the Southern Sierra in 1863 describing the giant sequoia trees as "distinguished strangers who have come down to us from another world."

WE MAY speak of "public land" or "private land," but the truth is we are in the presence of an ancient mystery—life itself—and the great life-communities within which all beings thrive and die. The pines were contemporary with the dinosaurs; the sequoias were a dominant forest that swept across the north Pacific rim and into much of Asia, long ago. Oaks are in several genus found on every continent except Antarctica. Indeed, "distinguished strangers from another world." They are all amazing. We live in a lovely and mysterious realm.

We all share a wish for the Sierra Nevada Forest, in its remarkable diversity, to survive and flourish into the far future, so that years from now people will still be able to take delight in the long views from Mount Lola or Mount Lyell, nap away an afternoon on the pine needle floor of a stand of big cinnamon-colored flaky-barked pines, shoot down a whitewater river, hear the occasional bark of a spotted owl, and also take fiber, firewood, and mushrooms home from it. Such hope is really basic—it is in no way extreme. But there are details here that will be hard to hammer out—the devil is in the details.

Forest history (and prehistory) may help us get a better understanding of the pre–white contact Sierra Forest and what it was presumably like. An open parklike forest of giant pines? A mosaic of different sorts of forest, including stable old brush lands? What changes took place in the forest in the post–white contact first century through logging, burning, and then fire suppression?

Since the last Ice Age, California has been a Mediterranean climate, that is to say, heavy rains in winter and a long scorching dry spell all summer. This creates a specific array of plants that can bear both winter-wet roots and long periods of drouth. Fire is a normal presence in such a climate, and over millions of years the fires produced a range of fire-adapted plants and a forest whose health depends on periodic burning. The Sierra forest is unlike that of the Southwest and the Rockies, and totally different from the west side Cascade conifer forests of the Pacific Northwest with its year-round rain.

So then, granted this set of determining conditions, what is the present state of affairs? What has been the effect of a century of fire-suppression? Where do the previous logging practices on both public and private land leave us? How much old growth remains, and how well has it been located?

What will it take to sustain both the wild natural world out there, to keep it diverse and flourishing, and at the same time allow for a human presence in and around the woods?

Many would agree that one measure of sustainability is the maintenance of the richness of the original biodiversity. Maintenance of biodiversity may sometimes be inconvenient, but it is the law of the land, as well as the ethical requirement that comes to us as stewards of the planet.

Sustainability might be measured in terms of the ecosystem energy budget. It has been suggested that for California to rely on third world timber imports when it has a fiber-producing capacity right at home would be unethical. By the same token, an energy-intensive sort of sustainability (logging and reforestation) simply mimics agribusiness, where productivity is forced higher by inputs from outside—especially

fossil fuel energy and chemicals: this is not true sustainability. If the money economy collapses, the even-age plantation created by it would collapse as well. Our wild forests have long had an elegant and self-sustaining nutrient and energy cycle, and staying within that should be a key measure of true sustainability.

A few words about time. Part of my work has been East Asian cultural history, and I have also researched and written on environmental history, especially forest history, in China and Japan. I have studied history and traveled in Southern Africa, most of East Asia, India, Nepal, and the Mediterranean Basin. There are some lessons in the experience of Asia and Europe that we would be very foolish to ignore. Take the forest history of the Mediterranean basin, the original "Mediterranean climate." Using a variety of tools and means, it has been established that in the time of Plato and Aristotle, 500 B.C., there was much oak-conifer forest throughout the whole basin, and some very impressive forests in the higher elevations. They were similar to the Sierra Nevadan oak-conifer complex. Although the pine species did not grow as huge as ponderosa and sugar pines, there were giant cedars (which come down to us as the "Cedars of Lebanon"). Areas of the Mediterranean hill country that we now see as *maquis* or *garrigue*, chaparral and rocky slopes, were then covered with trees. Springs have disappeared, and soils have long since eroded away. Old seaports have been buried under alluvial silt.

The Greek or Sicilian or Albanian or Spanish people who live there today have no knowledge of what their environment looked like in earlier times; they think it was always maquis, or brush. Following the studies of J. V. Thirgood, it seems that what happened in later Greek times and then throughout the Roman era was a process of steady deforestation. The mountains at the head of the Adriatic Sea had forests dedicated to the continual rebuilding of the Roman fleet. Thirgood says that in a Mediterranean-type forest where the soil dries out in its hot dry summers, when the canopy is reduced by logging below a certain percentage and then followed by the winter rains, a considerable amount of soil will be washed away. It might not happen in one century,

or even in two or three centuries, but over many centuries the forests are reduced to brush fields, and even replanting is no longer possible.

North India, especially the Himalayan foothills, have been thoroughly deforested. North and Central China were stripped of almost all forests by the fourteenth century. Ireland was denuded of oaks by the English, who turned them into ships. Intellectuals in Barcelona, Spain, whom I asked "what was your original vegetation here?" amazed me by saying, "We think there never was any original vegetation." In fact, that area was first logged by the Carthaginians. The Sierra Nevada too could eventually become a series of manzanita brush fields. With the pressure on it from a steadily growing population, a growth-fueled economy, militant consumerism with worldwide material aspirations, and a political system whose leaders change every four or eight years, the Sierra Nevada is defended by people with limited knowledge.

These environmental histories are cautionary. They tell us that our land planning must extend ahead more than a few decades. Even a few centuries may be insufficient. We must work on a really long time frame. We need to watch our steep slopes and our soils like hawks, leave a fair canopy when we log, and put health of the land ahead of short-term profit. Save what's left of the old growth for science and for the future. How fire plays into this clearly must be part of the discussion. In the local watersheds, in the universities, in public land agencies, and in the timber business, a surprisingly large number of people have come to understand and appreciate their public lands and all of nature far better than in the past. This is a big advance.

Someday there will be a Thousand-year Forest Plan. If talking about "one thousand years" seems unimaginably long, we should remember that the Department of Energy and the whole nuclear establishment are planning for a repository of spent but thoroughly dangerous radioactive material to be placed underground at Yucca Mountain in Nevada, and it will need to be overseen and guarded for at least ten thousand years. They have assured us that they will look after it for all that time.

We can be pretty sure that our descendants will be here a thousand years from now, and that they may not even know whether we did well

in our planning for them, but the nuclear waste will still be a big question. The choices we make in regard to our natural environment and our society have increasingly long-range implications in this hyper-informed but historically clueless speeded-up contemporary world. We are developing (some) good information. May we be granted the wisdom and time to use it.

A Note on Reality and Etiquette

I have an old friend in Montana named Tom Birch. He's a philosopher, teacher, hunter, and backcountry rambler. When asked why he so liked going into the wilderness Tom replied, "Wilderness treats me like a human being."

"What?" I said. "Yes. Treats me like a human being."

I asked, "What in the world makes you say that?"

Tom said, "I mean: it treats me like an adult. It doesn't try to protect me, coddle me, put up handrails for me, provide a policeman or social worker for me, adjust the heat, or even put out a pad to sleep on. And nobody knows where I am. For me, to be fully human is to be fully responsible to my own skills or lack of them, and to have the possibility of death always there at my right hand. Then, when you're fully vulnerable and on your own, you know what it feels like to be fully alive."

This is one of the clearest hard-core arguments for wilderness and for living on the wild edge that I know of. The Buddhists say, this is the way all of life is anyhow, we just don't normally recognize it. Nature is not fuzzy and warm. Nature is vulnerable, but it is also tough, and it will inevitably be last up at bat. Knowing that, we can assume that there are also a few fundamental matters of etiquette to be observed in regard to nature.

One of the oldest and most universal requirements of wild manners is to always express gratitude for what you take, to say thanks. When I worked at the Warm Springs Lumber Company's Camp A on the Warm Springs Indian Reservation in 1953, half the logging crew was Native American—Wasco, Yakima, and Warm Springs men. The fallers

would often smoke some sacred tobacco—usually Lucky Strikes—and say a little prayer before taking a big pine down. They meant it, and it makes all the difference in the world.

What was it our grandmothers taught us, way back then? "Take no more than you need, and don't waste." Profound morality—don't forget it.

Native Alaskans living in the Yukon said, "After you've done with a deer, don't scatter the bones out for the dogs or the other animals. Wrap them up, drop them in the river, and say 'thank you' one more time. If you don't do that, the deer won't want to come back and die for us again."

In the fall of 2000 I visited the "Cloud Gate" Zen Buddhist Nunnery deep in the mountains of South Korea. I went strolling on the broad temple grounds, with its many traditional buildings and gardens, and came on a huge old pine tree with low outstretching limbs extending over many hundreds of square feet. It was strikingly twisty. The low canopy was maybe eighty feet across. The outer edge was entirely surrounded by a two-foot-high, skillfully tied bamboo fence. It has a wooden sign on a post by it, written in Korean calligraphy. I asked a passing nun what it said. She told me, "It says this is a noble and honorable elderly tree, which has been here from the beginnings of the temple." Then she told me it was honored once a year by having many gallons of Korean rice alcohol poured carefully around the entire drip line. I said, "Honored?" And she said, "Yes, and to cheer it up."

So another rule of etiquette—besides saying "Thank you"—is to give something back. Our society has taken a lot from the Sierra Nevada. Now it's time to see what we can give back.

6.

The Mountain Spirit's True [No] Nature

■ ■ ■

WHEREVER there are mountains, there are rivers. Wherever there are mountains and rivers, there are spirits. Even Buddhism, with its astringent skepticism toward the power of deities, finds itself dealing with nature spirits from the old days. Poets and storytellers have throughout time stepped in to mediate between gods, nature, religion, and society.

It is well understood that each of us lives in a constructed world, for most purposes made up of unacknowledged social narratives so deeply embedded in our psyches that we rarely recognize them, let alone doubt their truth. To a degree they must conform to the actual case of "what is" since if they were too off, our stories would kill us. Some stories do.

Civilizations each have a history, which someone famously suggested is usually written by the winners. Each nation has a story it tells itself. Much of the worldview of contemporary developed societies is based on popular interpretations of nineteenth- and twentieth-century science. Perhaps the most pervasive and uncritically accepted developed-world faith is its belief in the idea of perpetual material progress, combined with an uncritical technological utopianism. At

This talk was given at the symposium "Occidental Civilization, Buddhism, and Zen," held in Paris on December 7, 2002, at the Maison de la Culture du Japon in Paris. Participants included Olivier Delbard and Katsunori Yamazato. It featured a performance of "The Mountain Spirit" poem from Snyder's *Mountains and Rivers Without End* with a traditional Noh musical accompaniment.

this moment the ideology of globalization finds ways to justify the destruction of natural environments and subsistence cultures, and the dislocation of inhabitory people, and then attacks independent labor and humanitarian movements wherever they try to organize.

Plato declared he would keep the poets out of his Republic because they "lied too much." Yet his own text, *The Republic*, is a great myth, a totalitarian vision that nobody took seriously until the twentieth century. The ideas were disastrous, whether they came through Hitler or Stalin. Poets, by contrast, stay with the simple old myths that are clearly just plain stories, and don't presume (as a rule) to try and formulate public policy. Poets' lies are easily seen through and not dangerous because they promise so little. Plato's Big Lie is sinister because it promises control and power to the leaders.

Poetry is healthy because there's no doubt that it belongs to the elusive and egalitarian realm of the imagination. This is no small matter, since the imagination is part of the life of the true self. The leaders of a nation cannot prescribe the peoples' deepest feelings; they can only hope to steer them. In this they contend with the poets and storytellers, and that's why Shelley said that poets are the unacknowledged legislators of the world. In truth the poets in some way *are* "legislators," and it is better and safer that they remain unacknowledged. Poets (meaning all artists) help give voice to the vernacular forms, styles, and values by which a society grounds itself in its own deep nature.

A deep cultural style is never "ideal," but is worth respecting and trusting to some degree, because it comes through the imagination and the heart. So poetry and art hang out near "nature." Better, they are close to *the wild*, which is to say, self-informing, self-organizing nature, the nature of actual reality. The imagination is the wild side of consciousness, free and unpredictable, but also shapely. The wild is also the flow of birth and death, dangerous but orderly in its own way. Traditional societies have stories and myths that help connect them with the natural world and to their own cultural histories. Sometimes the stories are in a poetic measure and can be sung or chanted. In preliterate times these chanted narratives were fundamental to the

society's identity. In more recent times, the songs of civilized poets keep referring back to the basics of the old tales. Seventeenth- and eighteenth-century British and French poets wrote poems that drew on the symbols and stories of Greek mythology. This is not trivial: Greek myths helped keep the wild side of European culture alive; had it died, it would have left Western Europe a lonelier place, with less love, less wilderness, and less joyous art.

It was Publius Ovidius Naso's *Metaphorphoses* that salvaged Greek myth for the inspiration of Western culture. Franz Boas, a German Jewish emigrant to North America, became chair of the Department of Anthropology at Columbia University. Together with his eminent students, working with brilliant Native American myth-poets like Charles Cultee the Chinook and Skaay the Haida, he started saving endangered Native American oral literature. Thanks in part to them, American Indian tales have enormously enriched contemporary North American hearts and minds.

Coyote Old Man, the trickster of many stories (quick, sly, lecherous, and also a carrier of valuable knowledge, a rebel, a survivor), has passed over from Native American culture to become familiar to contemporary readers. Old Man Coyote breaks down any dichotomous black-and-white sense of good and evil (Occidentals always run the risk of falling into simplistic dualism) and reminds us that wisdom and foolishness are often mingled hopelessly together like ghee stirred into milk. Contemporary North Americans poets are still struggling with Coyote tales. Their transgressive energy makes them extremely risky as well as painfully funny. Their fierce spiritual instruction is not always easy to perceive. The trickster motif is found (usually in milder form) everywhere. Oddly enough, the Zen tradition speaks of the Buddha himself, the great enlightened teacher, as a "trickster"—"Old Golden-Face, who has caught us in entangling vines."

Not all Coyote-tricksters are male. The American writer Ursula Le Guin has created a magical Coyote trickster woman in her story "Buffalo Gals, Won't You Come Out Tonight." Coyote the trickster is usually male though, for part of the joke is his boundless phallic

impropriety. In East Asia, Fox is a female trickster, and many of the stories tell of her mischief in seducing and then abandoning self-important young men.

Although Japan is supposedly a patriarchy, it has an emperor whose first spiritual obligation is to his ancestress the great Goddess of the Sun, Amaterasu. Once a year, we are told, he has a solitary ritual meal with her in a remote chamber at the Great Shrine of Ise. The sun in Japanese mythology is feminine. The earliest Chinese references to Japan—before Japan even had a writing system of its own—describe it as a land of tribes led by "Queen Pimiko." The ancient Chinese sources described these offshore island people as loving song, dance, and par-tying and said their religious leaders were women shamans. The Sun Goddess, in a pivotal early myth, is tricked into coming out from her retreat into a cave and putting the world into darkness, by the revealing dance of a rowdy goddess named Ame-no-Uzume and the uproari-ous laughter of the onlooking crowd of godlets on the broad riverbed gravels. Japan is richly endowed with female folklore figures. There are magical maidens who are also exquisitely sensitive birds, sweet old ladies who turn out to be cannibals, all-devouring brides, mountain-dwelling hags who admire human dancers, and many more.

One subject of many old tales is widely known as "Yamamba" or "The Old Woman of the Mountains." She is not really an old human woman but a timeless crone goddess, sometimes young but ragged, with a wild-haired baby boy. Her story migrated into the aristocratic Buddhist/Samurai culture of the early fifteenth century when she became the main character in the Noh play *Yamamba*. It is some-times attributed to Zeami, the "Shakespeare" of Noh. In the play, a young woman who has become a celebrity in the Capital for her dance called "Yamamba" is on a pilgrimage to the temple where her mother is buried. The route takes her over a high mountain pass where she and her guide are surprised by sudden nightfall. She is befriended by an old woman with a hut nearby, who seems to know of her and asks to see her "Yamamba" dance. When the dance finally takes place, it is hard to say who is really dancing. The real Yamamba is not so much angered that she has been appropriated by a human entertainer as she

is curious to see what the dancer will do. The young dancer is terrified. But when the time comes it is the old woman who dances; the young woman possibly merges with her, and there is only one dancer on the stage at the end.

The authors of the Noh play saw the ancient wanderer as Earth and Nature Herself, and present her as vexed by her task, the meaningless cycles of countless seasons, and the endless stream of birth and death through which she constantly passes. The play makes her into a powerful symbol of Enlightenment and simultaneous ignorance. She transcends her own existential doubt as she affirms the ineluctable color of each moment, even while walking her geological-time-scale rounds. She also finds occasional ways to secretly assist human beings. She's revealed as a kind of Bodhisattva, an enlightened ogress who is committed to laboring on until all beings can join together in Englightenment. The final dance itself is referred to as an *utsurimai*, "reflected dance." Human Culture (the young dancer) had become famous in the city by dancing as the Old Woman who signifies Wild Nature. Once in "wild nature" she is asked by the actual Old Woman of the Mountains to entertain her by performing her very dance of "nature," and as she does, the two become reflections of each other. The final turn is that Yamamba joins her (in one person) and is then imitating her, the human dancer. "Nature enjoys culture imitating nature, and then imitates culture doing so."

In the folklore versions of Yamamba's doings, the old ogress is not so benevolent. In one story she tells a lost traveler whom she is putting up for the night in her hut, "Whatever you do, don't look into that room!"—and goes out for firewood. He cannot resist opening the door, and he sees a room full of partially eaten corpses. The accommodating old woman is a cannibal. She instantly realizes what he has done, reveals her ogre character with white fangs and a long red tongue flapping out, and says "You did this to me! You humans did this to me!"—as Nature herself might indeed say to us all as our greed and trash push her to the breaking point. The Kabuki play *Kurozuka* tells this with chilling style.

The Buddhist teachings enabled the poets of Japan to take this witch,

ogress, demon woman from the folk tradition and transform her into a larger figure who is disclosing the condition of the impermanent world. We are all beings in constant change, charged with a sense of duty and a sense of beauty, and Yamamba points toward a way to be both at peace and of service. We can see our contemporary urban civilization itself as being represented by that charming and popular young dancer, face-to-face with her own scary ancient wild being in the dark woods.

It is worth noticing that in European culture the archetype of the old woman of the mountains (or dark forest) is seen as an evil witch, with no redeeming qualities. The play "Yamamba" presents a truth known to all of Buddhism: that Enlightenment or Self-realization can come in its own way to beings of many sorts in this vast spiritual-biological realm we all share. Angels and gods may appear angelic, but in fact they might still have unresolved angers and egos. Similarly demonic and devilish-looking characters may in truth have overcome their harsh nature and, though they look scary, may be sweet and generous, dedicated to helping others. (Dogen describes this as "Even though all things are liberated and not tied to anything they abide each in their own phenomenal expression.")

Jehovah himself, in the view of the Mahayana Buddhist philosophers of North India, is a splendid and powerful deity worshipped by people to the west of India, unfortunately under the delusion that he created the world. "He needs to do more meditation," they said. Yamamba is a spiritual being who has realized her true nature and become a Bodhisattva, but her teeth are still crooked, her long white hair stringy, her body still bent, and her fingernails long.

My years living in Japan and many walks in the hills and mountains of Kansai and the Japan Alps gave me the nerve to try and bring the "Old Woman of the Mountains" story to North America. In the poem "The Mountain Spirit" I draw on early intuitions of mountain spirits that came as I walked the wild peaks and ridges of North American ranges—the Cascades and the Sierra. Beyond that, I had the sense that "Yamamba" is a story the North American landscape is ready for, whether the human people are ready for it yet or not. My redaction is

significantly different from the East Asian source, though, and was in some parts virtually dictated to me as I sat one night under junipers in the timberline zone of the White Mountains of eastern California.

Even as Zeami (or whoever it was) appropriated this bit of archaic and archetypal lore from ancient Japan and brought Mahayana Buddhist insight to bear on it, transforming it into a work of high art, so I with "some nerve" took it to the western hemisphere. I gave it a new form echoing in part the Native American lore of wild spirits and the findings of geologists.

To go back to the term "true nature"—as that which is the ground of self, life, spirit, and art—we are still left with the puzzle, why did the great teacher Hakuin—speaking for the whole Ch'an/Zen tradition—say "true nature is no nature—far beyond mere doctrine"? (*Jishô sunawachi mushô nite / Sude ni keron o hanare tari.*) Dôgen, in the *Mountains and Waters Sutra*, making what I take to be a related point, says, "The power of the government does not reach into the mountains."

7.

The Path to Matsuyama

■ ■ ■

THIS IS a truly moving event for me. I hope to say a few words to celebrate the poetic culture of Japan, to acknowledge the great tradition of haiku, and to remember and honor the remarkable haiku poet Masaoka Shiki, who set a direction for poets right down to our time. And also, I offer my respects, as a visitor, to the mountains and rivers of Shikōku Island.

Though I feel forever a beginner in these matters, my love for poetry and its power remains ardent. When I was first invited to come to Matsuyama, I protested "I am not a haiku poet! Please be sure you understand that." But I was assured my selection was not a mistake. I hope not to disappoint that trust.

I was born in 1930, and I grew up on a farm in the Maritime Pacific Northwest, the rainy and deeply forested basin of Puget Sound and the lower reaches of the Columbia River. Our place was in the forested countryside north of Seattle. We kept milk cows and a flock of laying chickens, plus some ducks and geese. We had a kitchen garden and an orchard of ten or twelve fruit trees. There were several acres of fenced pasture and beyond that a thriving second-growth forest reaching to a far hill and beyond. As a child I had my share of chores on the farm with cows, chickens, the gardens, and firewood. I also spent a lot of time in the forests outside our fences, free to do my wandering, hunting, and plant gathering.

On receiving the "Masaoka Shiki International Haiku Grand Prize" from the Ehime Cultural Foundation in Matsuyama City, Japan, November 7, 2004.

I mention this because I now realize it was a premodern childhood. My sister and I were able to see and feel the seasons and their changes, moments of cloud and sky, the life and death of animals. We had the good luck to work on the land with our hands. My early admiration for Native American worldviews began somewhere in those days.

Although we had Japanese American neighbors and playmates whose parents were local farmers, I had little sense of what that meant. I knew we were at the far western edge of the North American continent and at the eastern edge of the great Pacific Ocean that reached the shores of China and Japan. Though we all spoke the American English language, we had no sense of belonging to Britain or Europe, and my Japanese American friends were as much at home in that forested West Coast landscape as I was.

It was my youthful love of nature that led me to learn about East Asia. Even as a boy I was deeply troubled by the destruction of the forests and the careless way that hunting—both waterfowl and deer— was conducted. My parents were nonreligious and did not teach us to follow any particular doctrine, so I felt free to explore all the world religions. I learned that the most important single ethical teaching of the Buddhist tradition is nonviolence toward all of nature, *ahimsa* (Japanese, *fusessho*). This led me to further investigating Buddhist teachings. At about twenty I started reading translations of Buddhist texts from India and China. The Dao De Jing (Japanese, *Dotokkyo*) and the Zhuang-zi (Japanese, *Chôshi*) helped broaden my view.

In a small college in Portland, Oregon, where I was admitted as a scholarship student, I first came upon haiku in the handsome hardcover pre–World War II books by Miyamori Asataro, published by Maruzen. They were accompanied by delicate little illustrations. The translations seemed stiff and artificial, but I still got a glimpse of the magic in the poems. Always drawn toward clarity and concision in literature, I paid great attention to Miyamori's text on the formal history and intention of haiku.

I was already reading widely in English-language poetry, ranging from Chaucer and William Blake to the twentieth-century moderns. But my circle of young would-be poets had further contact with East

Asian verse in avant-garde poetry circles, where Ezra Pound was a strong influence. He was the early and most famous proponent of Imagism, which in turn had been influenced in part by early twentieth-century discoveries of haiku. Haiku, as we know now, played a strong role in shaping early twentieth-century modernist poetics. It can be said that the Imagists did not quite grasp that haiku was more than just one concise image, but their own brief poems are keen and worthy.

Ezra Pound's work reinforced my curiosity about Chinese poetry, and soon I was reading Pound's translations from T'ang dynasty Chinese collections as well as translations by Witter Bynner, Arthur Waley, and many others. I was writing and publishing occasional poems in skinny little magazines and debating, arguing, and sharing poems with other young people. We all felt especially close to the works of William Carlos Williams, William Butler Yeats, T. S. Eliot, and Wallace Stevens, as well as Pound.

Reed College, a small but tough school, was expert at the presentation of the full scope of Occidental thought and history. We got an excellent humanities education from the ancient Mediterranean world to the Middle Ages, the Renaissance, the Enlightenment, the rise of science and Industrialism, Imperialism, and on down to our own current violent and confused era. Even back in the fifties they were teaching us something close to what today is known as "critical theory." It is said that "Those who will not learn from history are doomed to repeat it." I am still trying to learn from history *and* nature.

But for some of us, Occidental history and culture was clearly only half the story. Together with a small group of comrades, I was always on the lookout for more information about East Asian art and thought. Members of that circle of friends included Lew Welch, who after several fine books of poems committed suicide in the early seventies, and the late poet and novelist Philip Whalen. In the last years of his life Whalen was a Soto Zen priest, known as Zenshin, with a temple in San Francisco.

My generation of West Coast writers felt that North America had to be our true spiritual base. Our interest in Native American cultures and our lives walking and working in the West Coast landscapes made us

feel thoroughly at home. The Pacific realm and the great civilizations of the Far East were as vivid as any sense of our connection to Europe. Still—as we can see at this very moment in history—that European continent to the east of the Atlantic Ocean has a long arm: the United States as a whole is still subject to the powerful karmic effects of the Roman Empire and the Judeo-Christian tradition.

I was from a proud, somewhat educated farming and working family. After finishing college I went back to work. I went into the national forests to be a fire lookout, isolated while living in a tiny cabin on the top of a peak for a season. I sometimes worked as a summertime firefighter and wilderness ranger, and then I spent winters in San Francisco to be closer to the community of writers.

I discovered the four-volume set of haiku translations by R. H. Blyth that we all now know so well. Reading the four Blyth volumes gave me my first clear sense of the marvelous power of haiku. I lived with Blyth's translations for a long time and tried to learn to see our North American landscapes in the light of haiku sensibility. When I ran across Bashô's great instruction, "To learn of the pine tree, go to the pine," my path was set. The other reading of that era that helped shape my life were the books of D. T. Suzuki.

In the fall of 1953 I moved to Berkeley and entered as a graduate student in East Asian languages at the University of California. I read Chinese poetry with Dr. Chen Shih-hsiang and translated poems of the Chinese Zen poet Han-shan/Kanzan. I studied Japanese with Dr. Donald Shively.

In 1954, through Dr. Shively, I got to know the formidable American Buddhist scholar Ruth F. Sasaki, who had been married to the Japanese Zen Master Sasaki Shigetsu. They had met before World War II when he was teaching Rinzai Zen in a little zendo in New York City. He died during the war. Mrs. Sasaki returned to Kyoto after the war to continue her Zen training with Sasaki Shigetsu's Dharma brother, Goto Zuigan Roshi. She was also hard at work translating and publishing Zen texts. She offered to help me get to Kyoto, saying that it would deepen my knowledge of Japanese and Chinese, and give me an opportunity for firsthand Rinzai Zen practice. Just as I was preparing to leave the West

Coast, I got involved with the literary circles that are now remembered as the "Beat Generation" in San Francisco. I participated in poetry readings and had some minor publications. Those early poems already show the influence of haiku, with strong short verses contained within longer poems. This was a strategy that came to me through Williams and Pound.

I first arrived in Japan in May of 1956. Exposure to Buddhist scholars and translators soon brought me to the *Zenrin kushu*, that remarkable anthology of bits and pieces of Chinese poetry plus a number of folk proverbs used within the Zen world as part of the training dialogue. If one was looking at the possibilities of "short poems," the *Zenrin kushu* practice of "breaking up" Chinese poems would certainly have to be included. R. H. Blyth famously said, "The *Zenrin kushu* is Chinese poetry on its way to becoming haiku." Maybe somebody—one of the old Zen monk editors—realized that practically all poems are too long and that they'd be better off if they were cut up. So he cut up hundreds of Chinese poems and came out with new, shorter poems! A major scholarly North American translation of the *Zenrin kushu*, with extensive commentary, now exists. *Zen Sand* is by a Canadian Japanese monk-scholar who spent many years as an *unsui* at the Daitoku-ji Sodo in Kyoto, Victor Sôgen Hori, and is published by the University of Hawaii Press. He now teaches at McGill University.

I now know I was extremely fortunate to have been exposed to the classy "Zen culture" aspects of Kyoto. But as I traveled around Japan, I came to thoroughly appreciate popular culture, ordinary lives, and the brave irreverent progressive vitality of postwar Japanese life. I realized that the spirit of haiku comes as much from that daily-life spirit as it does from "high culture"—and still, haiku is totally refined.

One of my friends from early Kyoto days was Dr. Burton Watson. He was on Mrs. Ruth Sasaki's translation team at Daitoku-ji in the late fifties, working on Zen texts as well as his own projects. I joined that team as an assistant. Watson has lived in Japan almost continuously since that time, maintaining affiliations with Columbia University. He is without question the world's premier translator from both Chinese and Japanese into English. Though I had read translations

of Shiki before, it was Dr. Watson's versions published by Columbia University Press in 1997, *Masaoka Shiki: Selected Poems*, that enabled me to fully appreciate him. Janine Beichman wrote *Masaoka Shiki: His Life and Works*, first published in 1982, but I didn't read Beichman's book until after my exciting exposure to Shiki through Dr. Watson. We English- and American-language speakers are fortunate to have these two excellent books to give us access to a man who was a giant in the world of haiku poetry. (Watson did a volume of translations of another poet of Matsuyama City, Taneda Santoka, that was also published by Columbia University Press, in 2003. It is titled *For All My Walking*. It is a delightful volume.)

I continued to live and study in Kyoto until 1968. My ability to speak and read Japanese improved a bit, though I am still embarrassed by how clumsy I am with this elegant language. I managed to read haiku in the original just enough to comprehend that the power of haiku poetry is not only from clear images, or vivid presentation of the moment, or transcendent insight into nature and the world, but in the marvelous creative play with the language. Poetry always comes down to language—if the choice of words, the tricks of the syntax, are not exactly right, whatever other virtues a piece of writing might have, it is not a poem. (These are the standards we apply to poetry in our own language. Poems in translation of course can not be judged this way. "Images," however, are translatable.)

What pleasure to recall just a few of Masaoka Shiki's haiku (translated by Burton Watson):

> *inazuma ya / tarai no soko no / wasure-mizu*

> Lightning flash—
> in the bottom of the basin,
> water someone forgot to throw out

—which I remember almost every time I bend over and wash my face, hoping for a flash of light! And,

yuki nokoru / itadaki hitotsu / kuni-zakai

A single peak,
snow still on it—
that's where the province ends

—because from where I live (in the mountains of California) there
is a mountain not too far to the east forever with springtime snow. I
always think "beyond that is the desert state of Nevada"—and remem-
ber Shiki.

But perhaps most interesting for me is this:

nehanzô / hotoke hitori / waraikeri

Picture of the Buddha
entering Nirvana—
one person is laughing!

When I was a Zen student in Kyoto my teacher once gave me a little
testing-koan that was "In the Buddha's Nirvana-picture, everyone is
crying. Why are they crying?" Some years later I find Shiki's *nehanzô*
haiku, and I can never stop laughing. What a fresh mind he had!

I returned to North America in 1968. In 1970 I moved with my family
to a remote plot of forest land in the Sierra Nevada at the thousand-
meter elevation—pine and oak woods. We built a house and have
made that our home base ever since.

Honoring the haiku sensibility, I look for what would be the seasonal
signals, *kigo*, in our Mediterranean middle-elevation Sierra Mountain
landscape. What xeric aromatic herbs and flowers, what birds, what
weather signals will we find? They are different from Japan. I read
translations of the myths and tales of the Native people who once
lived where I live now, from the Nisenan language (which is no longer
spoken), and I can see how much they valued the magic of the wood-
pecker, the sly character of fox, and the trickster coyote. High-flying

migratory sandhill cranes pass north in the spring and south in the fall directly over my house. They have been on this path for at least a million years.

The Euro-, African, and Asian Americans are not even three hundred years on the West Coast of North America, and it will be several centuries yet before our poetic vocabulary adequately matches the land. The haiku tradition gives us a few pointers that we need as we begin this process, a process that will be part of making a culture and a home in North America for the long future ahead.

The ancient Buddhist teaching of non-harming and respect for all of nature, which is quietly present within the haiku tradition, is an ethical precept we are in greater need of now than ever, as the explosive energy of the modern industrial world pushes relentlessly toward a terminal exploitation of all the resources of the planet.

But how has Japanese haiku poetry been discovered worldwide? Though haiku may be considered old-fashioned and conservative by some people in Japan, in the rest of the world it is received as fresh, new, experimental, youthful and playful, unpretentious, and available to students and beginners who want to try out a poetic way of speaking.

There's hardly a literate culture on earth that doesn't have some translation of Japanese haiku in its poetry anthologies. From this, an international non-Japanese haiku movement has begun, which takes the idea of haiku in hundreds of new directions. School teachers in Denmark, Italy, or California have no hesitation giving translations of Japanese haiku to their students, telling the children to look around, see what they see, have a thought, make an image, and write their own brief poem. Children everywhere are learning about poetry and about themselves in the world in just this way. Though this may not be entirely true to the haiku tradition itself, it is of immense value to young people to have their language and imagination liberated. Short poems and haiku inspire them more than the usual English- or European-language poetry, which may seem to children either too formal or too modern and experimental. The haiku tradition is now part of a worldwide experimental movement in freshly teaching

poetry in the schools. As a teacher in the graduate creative writing program at the University of California at Davis, I taught the haiku tradition to serious older students, using Robert Hass's superb book *The Essential Haiku*, and it was as surprising and useful to these sophisticated young adults as to any schoolchild. Haiku amazingly reaches every class, every age.

I introduced my stepdaughter to poetry at age eight with the idea of haiku! I read and recited haiku and other short poems to her and then said, "You do it yourself! Look at something and say it—look at something else and say it—and then tell me what your mind says." She got the hang of it and soon was delightedly producing these personal mini-poem utterances. We don't call them haiku.

Eventually somehow I became known as a poet. My poetic work has had many influences: traditional ballads and folk songs, William Blake, Walt Whitman, Robinson Jeffers, Ezra Pound, Native American songs and poems, Noh drama, Zen sayings, Frederico Garcia Lorca, midcentury Bay Area poetic masters like Robert Duncan, and much more. But the influence from haiku and from the Chinese is, I think, the deepest. Though not a "haiku poet," I have written a number of brief poems, some of which may approach the haiku aesthetic. They fit especially into one large project, *Mountains and Rivers Without End*, where I am searching for ways to talk about the natural landscapes and old myths and stories of the whole planet.

Over the years I have made many trips to Japan and continued to learn from contemporary Japanese poets, especially Tanikawa Shuntaro, Ooka Makoto, and Sakaki Nanao—Nanao is a truly unique figure. The contemporary Korean poet Ko Un's very short Zen (Korean *Son*)–inspired poems are hugely pleasurable and very subtle. I enjoyed getting to know the haiku of Dr. Arima Akito through the translations of Miyashita Emiko and Lee Gurga.

"Yves Bonnefoy in his excellent presentation here in 2000, said that we in the Occident are not experiencing 'a kind of haiku fashion' but an awakening to a necessary and fundamental reference, which can only remain at the center of Western poetic thought." And he goes on to say that all these exchanges are for the "greater good of poetry,

which is our common good and one of the few means that remain for preserving society from the dangers that beset it."

It is quite to be expected that Mr. Bonnefoy and I, French and American, each in our own way, invoke haiku as a benefit and a value in matters of the troubled world today. People are always asking "what's the use of poetry?" The mystery of language, the poetic imagination, and the mind of compassion are roughly one and the same, and through poetry perhaps they can keep guiding the world toward occasional moments of peace, gratitude, and delight. One hesitates to ask for more.

A *gassho* to the great poets of the land, especially Masaoka Shiki. I would ask the mountains and rivers to overlook my brashness for having the nerve to say hello: and as it goes in Sanskrit, *Sarvamangalam*, "May good fortune come to All Beings."

8.

Writers and the War Against Nature

■ ■ ■

THOSE WHO LOVE THE WORLD

I GREW UP in the maritime Pacific Northwest, on a farm north of Seattle, where we kept a hen flock, had a small orchard, and tended dairy cows. My uncles were loggers, merchant seamen, and fishermen.

After college, where I studied anthropology, literature, and East Asian culture, I had no choice but to go back to working in the woods and at sea. In the late fifties I spent nine months working in the engine room on an American-flag oil tanker that hired me out of the port of Yokohama. I was a member of the National Maritime Union, had my seaman's papers, and it wasn't hard to pick up a job in almost any port of the world. That ship kept me at sea for a continuous nine months. Two things touched me deeply on that job: One was the stars, night after night, at every latitude, including way below the equator. With my little star book and red-beam flashlight I mastered the constellations of the southern hemisphere. The other was getting to know the birds of the ocean. I loved watching the albatross—a few of those huge graceful birds would always be cruising along behind our ship, trailing the wake for bits of food. I learned that a Wandering Albatross (of the southern hemisphere) might fly a million miles in one lifetime, and that it takes a pair of them almost a year to raise one chick. Night and day, they always followed us, and if they ever slept it seems it was on the wing.

Just this January a study was released describing the sudden decline of albatross numbers worldwide. It even prompted an editorial in the

New York Times (January 20, 2005). Their sharp decline is attributed to much death by drowning. The long-line fishing boats lay out lines with bait and hooks that go miles back, dragging just below the surface. An albatross will go for the bait, get hooked, and be pulled down to drown. As many as one hundred thousand a year are estimated to perish in this way, enough to threaten the survival of the species if it keeps up. What have the albatross, "Distinguished strangers who have come down to us from another world," ever done to us? The editorial concludes, "The long-line fishing fleet is over-harvesting the air as well as the sea."

Out on the South Pacific in 1958, watching the soaring albatrosses from the stern of a ship, I could never have guessed that their lives would be threatened by industrial societies, turning them into "collateral damage" of the affluent appetite for *ahi*, and *maguro*. Yet this is just a tiny example of the long reach of the globalized economy and the consumer society into the wild earth's remote places. A recent book on global logging and deforestation is titled *Strangely Like War*. What is happening now to nature worldwide, to plant life and wildlife, in ocean, grassland, forest, savannah, and desert in all spaces and habitat can be likened to a war against nature.

Although human beings have interacted with nature for millennia, and sometimes destructively so, it was never quite like "war." The active defense of nature has been joined by a few artists and writers who have entered the fight on "the wild side" along with subsistence peoples, indigenous spiritual leaders, and many courageous scientists, conservationists, and environmentalists worldwide.

There is a tame, and also a wild, side to the human mind. The tame side, like a farmer's field, has been disciplined and cultivated to produce a desired yield. It is useful but limited. The wild side is larger, deeper, more complex, and though it cannot be fully known, it can be explored. The explorers of the wild mind are often writers and artists. The "poetic imagination" of which William Blake so eloquently spoke is the territory of wild mind. It has landscapes and creatures within it that will surprise us. It can refresh us and scare us. Wild mind reflects the larger truth of our ancient selves, of our ancient animal and spiritual selves.

The French anthropologist Claude Levi-Strauss once said something like "Art survives within modern civilization rather like little islands of wilderness saved to show us where we came from." Someone else once said that what makes writing good is the wildness in it. The wildness gives heart, courage, love, spirit, danger, compassion, skill, fierceness and sweetness—all at once—to language. From ancient times storytellers, poets, and dramatists have presented the world in all its fullness: plants, animals, men and women, changing shape—speaking multiple languages—inter-marrying—traveling to the sky and under the earth. The great myths and folktales of human magic and nature's power were our education for ten thousand years. Whether they know it or not, even modern writers draw strength from the wild side.

How can artists and writers manage to join in the defense of the planet and wild nature? Writers and artists by their very work "bear witness." They don't wield financial, governmental, or military power. However, at the outset they were given, as in fairy tales, two "magic gifts": One is "The mirror of truth." Whatever they hold this mirror up to is shown in its actual form, and the truth must come out. May we use that mirror well! The second is a "heart of compassion," which is to say the ability to feel and know the pains and delights of other people, and to weave that feeling into their art. For some this compassion can extend to all creatures and to the earth itself. In a way nature even borrows the voices of some writers and artists. Anciently this was a shamanistic role where the singer, dancer, or storyteller embodied a force, appearing as a bear dancer or a crane dancer, and became one with a spirit or creature. Today, such a role is played by the writer who finds herself a spokesperson for nonhuman entities communicating to the human realm through dance or song. This could be called "speaking on behalf of nature" in the ancient way.

Song, story, and dance are fundamental to all later "civilized" culture. In archaic times these were unified in dramatic performance, back when drama and religious ceremony were one. They are reunited today in the highest and greatest of performance arts—the grand scale

of European opera and ballet, the spare and disciplined elegance of Japanese Noh theater, the grand and almost timeless dance-and-story of Indonesian Gamelan, the wit and hardiness of Bertolt Brecht's plays, or the fierce and stunningly beautiful intensity of Korean P'ansori performance. Performance is of key importance because this phenomenal world and all life is, of itself, not a book but a performance.

For a writer or artist to become an advocate for nature, he or she must become a lover of that vast world of energies and ecologies. Because I was brought up in a remote rural district, instead of having kids to play with I sometimes had to entertain myself by exploring the forest surrounding our farm, observing the dozens of bird species and occasional deer, fox, or bobcat; sometimes hunting, sometimes gathering plants that I could sell to herb buyers for a few pennies, sometimes camping out alone for several days at a time. Heavy logging was going on in the nearby hills.

At fifteen I got into the higher mountains of the Cascade range in Washington State, starting with the ridges and high meadows around the snow-covered volcano called Mount Saint Helens, or Luwit, a nine-thousand-foot peak just north of the Columbia River. This is what I finally chose to write about in my book *Danger on Peaks*:

THE CLIMB

Walking the nearby ridges and perching on the cliffs of Coldwater Mountain, I memorized the upper volcano. The big and little Lizards (lava ridges with their heads uphill), the Dogshead, with a broad bulge of brown rock and white snowpatches making it look faintly like a St. Bernard. The higher-up icefields with the schrund and wide crevasses, and the approach slopes from timberline. Who wouldn't take the chance to climb a snowpeak and get the long view?

Two years later the chance came. Our guide was an old-time Mazama from Tigard in Oregon. His climbing life went back to

World War One. Then he got a big orchard. He wore a tall black felt hunting hat, high corked loggers-boots, stagged-off pants, and carried the old style alpenstock. We put white zinc oxide paste on our noses and foreheads, each got our own alpenstock, and we wore metal-rimmed dark goggles like Sherpas in the thirties. We set out climbing the slidey pumice lower slopes well before dawn.

Step by step, breath by breath—no rush, no pain. Onto the snow on Forsyth Glacier, over the rocks of the Dogshead, getting a lesson in alpenstock self-arrest, a talk on safety and patience, and then on to the next phase: ice. Threading around crevasses, climbing slow, we made our way to the summit just like Issa's

> "Inch by inch
> little snail
> creep up Mt. Fuji"

West Coast snowpeaks are too much! They are too far above the surrounding lands. There is a break between. They are in a different world. If you want to get a view of the world you live in, climb a little rocky mountain with a neat small peak. But the big snowpeaks pierce the realm of clouds and cranes, rest in the zone of five-colored banners and writhing crackling dragons in veils of ragged mist and frost-crystals, into a pure transparency of blue.

St. Helens' summit is smooth and broad, a place to nod, to sit and write, to watch what's higher in the sky and do a little dance. Whatever the numbers say, snowpeaks are always far higher than the highest airplanes ever get. I made my petition to the shapely mountain, "Please help this life." When I tried to look over and down to the world below—*there was nothing there.*

And then we grouped up to descend. The afternoon snow was perfect for glissade and leaning on our stocks we slid and skidded between cracks and thumps into soft snow, dodged lava slabs, got

into the open snowfield slopes and almost flew to the soft pumice ridges below. Coming down is so fast! Still high we walked the three-mile dirt road back to the lake.

Atomic Dawn

The day I first climbed Mt. Saint Helens was August 13, 1945.

Spirit Lake was far from the cities of the valley, and news came slow. Though the first atomic bomb was dropped on Hiroshima August 6 and the second dropped on Nagasaki August 9, photographs didn't appear in the *Portland Oregonian* until August 12. Those papers must have been driven in to Spirit Lake on the 13th. Early on the morning of the 14th I walked over to the lodge to check the bulletin board. There were whole pages of the paper pinned up: photos of a blasted city from the air, the estimate of 150,000 dead in Hiroshima alone, the American scientist quoted saying "nothing will grow there again for seventy years." The morning sun on my shoulders, the fir forest smell and the big tree shadows; feet in thin moccasins feeling the ground, and my heart still one with the snowpeak mountain at my back. Horrified, blaming scientists and politicians and the governments of the world, I swore a vow to myself, something like, "By the purity and beauty and permanence of Mt. St. Helens, I will fight against this cruel destructive power and those who would seek to use it, for all my life."

The statement in that 1945 newspaper saying that nature would be blighted for decades to come astounded me almost as much as the enormity of the loss of innocent human life. Already a conservationist, I later went on to be active in the anti-nuclear movement as a student and argued and struggled against the use and proliferation of nuclear weapons. Even though it seemed at times that these efforts were naive and hopeless, we persevered.

During my college years I was studying the philosophies and religions of the world. A central teaching of the Buddhist tradition is nonviolence toward all of nature, *ahimsa*. This seemed absolutely right to me. In the Abrahamic religions, "Thou shalt not kill" applies only to human beings. In Socialist thought as well, human beings are all-important, and with the "labor theory of value" it is as though organic nature contributes nothing of worth. Later it came to me, green plants doing photosynthesis are the ultimate working class. Nature creates the first level of value, labor the second.

In the *Lun yü*—the Confucian "Analects"—we can see how the Master called for Etiquette in regard to nature as well as human society (7.27). Almost all of the later "high civilizations" have been the sort of social organizations that alienate humans from their own biological and spiritual heritage.

While I was laboring in the forests, most of my fellow loggers were Native Americans of the Wasco and Wishram tribes of eastern Oregon. From them I learned that it was possible to be a hunter and a fisherman with a spiritual attitude of deep gratitude and nonviolence.

After some work as a graduate student at the University of California at Berkeley, I finally got a chance to go to Asia. I lived for a while in a Zen practice hall in Kyoto, Japan, and studied with a Zen teacher in the Rinzai (Chinese, *Linji*) tradition. I took the precepts under my teacher, who told me that "Of all the precepts, the first precept is most important and contains the others: *ahimsa*, nonharming, 'Cause the least possible harm.'" To live with that precept is a challenge—he once said to me, "How do you not harm a fence? How would you save a ghost?"

I lived in Japan for ten years, partly in the monastery but also in my own little house, and supported myself by teaching English conversation to Japanese salarymen. I asked my adult students, "Why are you so intent on learning English?" They answered, "Because we intend to extend our economic influence worldwide, and English is the international language." I didn't take them seriously.

In my spare time I hiked in the local mountains, learned East Asian plants and birds, and started seriously reading scientific books on ecology and biology. All those essays analyzing food chains and food webs—this was a science, I realized, dealing with energy exchange and the natural hierarchies of various living systems. "When energy passes through a system it tends to organize that system," someone wrote. It finally came to me that this was about "eating each other"—almost as a sacrament. I wrote my first truly ecological poem, which explores the essential qualities of human foods:

Song of the Taste

Eating the living germs of grasses
Eating the ova of large birds

 the fleshy sweetness packed
 around the sperm of swaying trees

The muscles of the flanks and thighs of
 soft-voiced cows
 the bounce in the lamb's leap
 the swish in the ox's tail

Eating roots grown swoll
 inside the soil.

Drawing on life of living
 clustered points of light spun
 out of space
hidden in the grape.

Eating each other's seed
 eating
ah, each other.

Kissing the lover in the mouth of bread:
 lip to lip.

This innocent celebratory poem went straight to the question of conflict between the ethics of *ahimsa*, nonviolence, "respect for all beings," and the lives of necessity and subsistence of indigenous peoples and Native Americans I had known. They still practiced ceremonies of gratitude and were careful not to present themselves as superior to other life forms. Ahimsa taken too literally leaves out the life of the world and makes the rabbit virtuous but the hawk evil. People who must fish and hunt to live can enter into the process with gratitude and care, and no arrogant assumptions of human privilege. This cannot come from "thinking about" nature; it must come from being *within* nature.

There are plenty of people of influence and authority in the churches, in industry, the universities, and high in government who still like to describe nature as "red in tooth and claw" (a line of Alfred Tennyson's)—a fundamental misunderstanding—and use it as part of the justification for the war against nature.

The organic life of the planet has maintained itself, constantly changing, and has gone through and recovered from several enormous catastrophic events over hundreds of millions of years. Now we are at another potentially disastrous time for the organic world. The overdeveloped world's impact on air, water, soil, wildlife, and plant life causes species extinctions, poisons air and water, leaves mountains with mudslides but no trees, and gives us soil that can't grow food without the continuous subsidy provided by fossil fuels. As we learned over time to positively work for peace to head off the possibilities of war, so now we must work for sustainable biological practices and a faith that embraces wild nature if we are to reverse the prospect of continually dwindling resources and rising human populations.

One can ask what might it take to have an agriculture that does not degrade the soils, a fishery that does not deplete the ocean, a forestry that keeps watersheds and ecosystems intact, population policies that respect human sexuality and personality while holding numbers down, and energy policies that do not set off fierce little wars. These are the key questions worth our lifetimes and more.

Many of our leaders assume that the track we're on will go on forever and nobody will learn much; politics as usual. It's the same old

engineering, business, and governmental message with its lank rhetoric of data and management. Or, when the talk turns to "sustainability," the focus is on a limited ecological-engineering model that might guarantee a specific resource for a while longer (like grass, water, or trees) but lacks the vision to imagine the health of the whole planet. An ethical position that would accord intrinsic value to nonhuman nature, and would see human beings as involved in moral as well as practical choices in regard to the natural world, would make all the difference.

"As . . . a dewdrop, a bubble, a cloud, a flash of lightning, view all created things." Thus ends the *Diamond Sutra*, reminding us of irreducible impermanence. Sustainability cannot mean some kind of permanence. A waggish commentary says "Sustainability is a physical impossibility. But it is a very nice sentiment." The quest for permanence has always led us astray—whether in building stone castles, Great Walls, pyramids and tombs for pharaohs, great navies, giant cathedrals to ease us toward heaven, or cold war–scale weapons systems guaranteeing mutually assured destruction. We must live with change, like a bird on the wing, and doing so—let all the other beings live on too. Not permanence, but living in harmony with the Way.

The albatross, all sixteen species of them, are companions with us on earth, sailing on their own way, of no use to us humans, and we should be no use to them. They can be friends at a distance, fellow creatures in the stream of evolution. This is fundamental etiquette. We do not need to crowd in on them, look at them, dream or write about them.

So, back to those key questions, what would it take? We know that science and the arts can be allies. We need far more women in politics. We need a religious view that embraces nature and does not fear science; business leaders who know and accept ecological and spiritual limits; political leaders who have spent time working in schools, factories, or farms, and maybe a few who still write poems. We need intellectual and academic leaders who have studied both history and ecology and who like to dance and cook. We need poets and novelists who pay no attention to literary critics. But what we ultimately need most are human beings who love the world.

Poems, novels, plays, with their great deep minds of story, awaken the

Heart of Compassion. And so they confound the economic markets, rattle the empires, and open us up to the actually existing human and non-human world. *Performance* is art in motion; in the moment; both enactment and embodiment. This is exactly what nature herself is.

> Soaring just over the sea-foam
> riding the wind of the endless waves
> albatross, out there, way
>
> away, a far cry
> down from the sky

9.

Entering the Fiftieth Millennium

■ ■ ■

L ET'S SAY we're about to enter not the twenty-first century but the fiftieth millennium. Since the various cultural calendars (Hindu, Jewish, Islamic, Christian, Japanese) are each within terms of their own stories, we can ask what calendar would be suggested to us by the implicit narrative of Euro-American science—since that provides so much of our contemporary educated worldview. We might come up with a "Homo sapiens calendar" that starts at about 40,000 years before the present (B.P.), in the Gravettian/Aurignacian era when the human tool kit (already long sophisticated) began to be decorated with graphs and emblems and when figurines were produced not for practical use but apparently for magic or beauty.

Rethinking our calendar in this way is made possible by the research and discoveries of the last century in physical anthropology, paleontology, archaeology, and cultural anthropology. The scholars of hominid history are uncovering a constantly larger past in which the earlier members of our species continually appear to be smarter, more accomplished, more adept, and more complex than we had previously believed. We humans are constantly revising the story we tell about ourselves. The main challenge is to keep this unfolding story modestly reliable.

One of my neopagan friends, an ethnobotanist and prehistorian, complains about how the Christians have callously appropriated his sacred solstice ceremonies. "Our fir tree of lights and gifts," he says, "has been swept into an orgy of consumerism, no longer remembered

as a sign of the return of the sun," and, "People have totally forgotten that the gifts brought from the north by Santa Claus are spiritual, not material; and his red clothes, white trim, round body, and northern habitat show that he represents the incredibly psychoactive mushroom *Amanita muscaria.*"

My friend is one of several poet-scholars I know who study deep history (a term he prefers to "prehistory")—in this case that of Europe —for clues and guides to understanding the creature that we have become and how we got here, the better to steer our way into the future. Such studies are especially useful for artists.

I went to France one summer to further pursue my own interest in the Upper Paleolithic. Southwest Europe has large areas of karst plateau, which allows for caves by the thousands, some of them enormous. Quite a few were decorated by Upper Paleolithic people. With the help of the poet and paleo-art historian Clayton Eshleman, my wife and I visited many sites and saw a major sampling of the cave art of southwest Europe, in the Dordogne and the Pyrenees. Places like Pêche-merle, Cougnac, Niaux, El Portel, Lascaux, and Trois Frères. The cave art, with its finger tracings, engravings, hand stencils, outline drawings, and polychrome paintings, flourished 10,000 to 35,000 years ago. The Paleolithic cave and portable art of Europe thus constitute a 25,000-year continuous artistic and cultural tradition. The people who did this were fully Homo sapiens and, it must be clearly stated, not just ancestors of the people of Europe but in a gene pool so old that it is to some degree ancestor to everyone everywhere. The art they left us is a heritage for people of the whole world.

This tradition is full of puzzles. The artwork is often placed far back in the caves, in places almost inaccessible. The quality fluctuates wildly. Animals can be painted with exquisite attention, but there are relatively few human figures, and they are strangely crude. Almost no plants are represented. Birds and fish are scarce compared to mammals. Some animal paintings, as at Niaux, appear unfinished, with the feet left off.

The theories and explanations from the twentieth-century cave-art specialists—the great Abbe Breuil and the redoubtable André

Leroi-Gourhan—don't quite work. The hunting-magic theory, which holds that the paintings of animals were to increase the take in the hunt, is contradicted by the fact that the majority of animal representations are of wild horses, which were not a big food item, and that the animals most commonly consumed, red deer and reindeer, are depicted in very small number. The horse was not yet domesticated, so why this fascination for horses? My wife, Carole, suggests that maybe the artists were a guild of teenage girls. The bison is a close second, however, and was a food source.

The other most commonly represented animals, the huge Pleistocene bison and the aurochs, a huge *bos* (living in the forests of northern Europe until the sixteenth century), were apparently too large and dangerous to be major hunting prey. Ibex, chamois, and panther occasionally show up, but they were not major food items. There are also pictures of animals long extinct now—woolly rhinoceros, mammoth, cave bear, giant elk.

In the art of early civilized times, there was a fascination with large predators—in particular, the charismatic Anatolian lions and the brown bears from which the word *arctic* derives. Big predators were abundant in the Paleolithic, but sketches or paintings of them are scarce in nearly all caves. It was the bears who may have first used the caves and entirely covered the walls of some, like Rouffignac, with long scratches. Seeing this may have given the first impetus to humans to do their own graffiti.

The theory that these works were part of a shamanistic and ceremonial cultural practice, though likely enough, is still just speculation. There have been attempts to read some narratives out of certain graphic combinations, but that too cannot be verified.

After several decades of research and comparison, it came to seem that cave art began with hand stencils and crude engravings around 32,000 B.P. and progressively evolved through time to an artistic climax at the Lascaux cave. This is the most famous of the caves, discovered during World War II. It is generally felt to contain the most remarkable and lovely of all the world's cave art. The polychrome paintings are dated at around 17,000 B.P. In the summer of 1996 I had

the rare good fortune to be admitted to *le vraie grotte* of Lascaux (as well as the replica, which is itself excellent and what all but a handful of people now see). I can testify. There's an eighteen-foot-long painting of an aurochs arcing across a ceiling twelve feet above the floor. A sort of Lascaux style is then perceived as coming down in other, later caves, excellent work, up to the Salon Noir in the Niaux cave in the Ariège, dated about 11,500 B.P. After that, cave art stops being made, many caves were closed up from landslides or cave-ins, and they were forgotten.

Until quite recently everyone was pretty comfortable with this theoretical evolutionary chronology, which fits our contemporary wish to believe that things get better through time. But in 1994 some enthusiastic speleologists found a new cave, on the Ardèche, a tributary of the Rhone. Squeezing through narrow cracks and not expecting much, they almost tumbled into a fifty-foot-high hall and a quarter mile of passageways of linked chambers full of magnificent depictions that were the equal of anything at Lascaux. There are a few animals shown here that are totally new to cave art. Images of woolly rhinoceros and the Pleistocene maneless lion, which are rare in other caves, are the most numerous. This site is now known, after one of the lead discoverers, as the Chauvet cave.

The French scientists did their initial carbon dating, and were puzzled, and looked again, and had to conclude that these marvelous paintings were around 32,000 years old, 15,000 years older than those at Lascaux—almost as distant in time from Lascaux as Lascaux is from us. The idea of a progressive history to cave art is seriously in question. A new, and again larger, sense of the Homo sapiens story has opened up for us, and the beginnings of art are pushed even further back in time.

I wrote in my notebook:

Out of the turning and twisting calcined cave walls, a sea of fissures, calcite concretions, stalactites, old claw-scratchings of cave bears, floors of bear wallows & slides; the human finger-tracings in clay,

early scribblings, scratched-in lines and sketchy little engravings of half-done creatures or just abstract signs, lines crossed over lines, images over images; out of this ancient swirl of graffiti rise up the exquisite figures of animals: swimming deer with antler cocked up, a pride of lions with noble profiles, fat wild horses, great bodied bison, huge-horned wild bulls, antlered elk; painted and powerfully outlined creatures alive with the life that art gives: on the long-lost mineraled walls below ground. Crisp, economical, swift, sometimes hasty; fitting into the space, fitting over other paintings, spread across . . . outlined in calligraphic confident curving lines. Not photo-realistic, but true.

To have done this took a mind that could clearly observe and hold within a wealth of sounds, smells, and images and then carry them deep underground and re-create them. The reasons elude our understanding. For sure the effort took organization and planning to bring off: we have found stone lamps and evidence of lighting supplies and traces of ground pigments sometimes obtained from far away. The people must have gathered supplies of food, dried grass for bedding, poles for scaffolding. Someone was doing arts administration.

One important reminder here is, as T. S. Eliot said when writing of Magdalenian art, "Art never improves. There is no progress in art." Art that moves us today can be from anywhere, any time. This is quite true, in certain ways, for the literary arts as well.

The cave paintings had their own roles to play back in the late Pleistocene. Having been protected by the steady temperatures of the underground, they return to human eyes again today, and across the millennia can move us. No master realist painter of the last five hundred years could better those painted critters of the past: they totally do what they do, without room for improvement.

And there may be no "progress" in religion, in Practice, or in the Dharma, either. There was an Ancient Buddha. There were archaic Bodhisattvas. All that we have to study of them is their shards and paintings.

What was the future? One answer might be, "The future was to have been further progress, an improvement over our present condition." This is more in question now. The deep past also confounds the future by suggesting how little we can agree on what is good.

If our ancient rock artists skipped out on painting humans, it just may be that they knew more than enough about themselves and could turn their attention wholeheartedly to the nonhuman other. In any case the range of their art embraces both abstract and unreadable signs and graphs and a richly portrayed world of what today we call "faunal biodiversity." They gave us a picture of their animal environment with as much pride and art as if they were giving us their very selves.

Maybe in some way they speak from a spirit that is in line with Dôgen's comment, "We study the self to forget the self. When you forget the self, you can become one with the ten thousand things."

We have no way of knowing what the verbal arts of 35,000 years ago might have been. It is possible that the languages of that time were in no way inferior in complexity, sophistication, or richness to the languages spoken today. It's not far-fetched to think that if the paintings were so good, the poems and songs must have been of equal quality.

One can imagine myths and tales of people, places, and animals. In poetry or song, I fancy wild horse chants, "salutes" (as are sung in some parts of Africa) to each creature, little lyrics that intensify some element in a narrative, a kind of deep song—*cante jondo*—to go together with deep history; or on the other side, quick "bison haiku."

It was all in the realm of orality, which as we well know can support a rich and intense "literary" culture that is often interacting with dance, song, and story, such as do our prime high arts today, opera and ballet.

Today, then: the Franco-Anglo creole known as English has become the world's second language and as such is a major bearer of diverse literary cultures. English is and will be all the more a future host to a truly multicultural "rainbow" of writings. The rich history of the English language tradition is like a kiva full of lore, to be studied and treasured by writers and scholars wherever they may find themselves

on the planet. It will also continue to diversify and to embrace words and pronunciations that will move it farther and farther from London Town. Even as I deliberately take my membership to be North American and feel distant from much of European culture, I count myself fortunate to have been born a native speaker of English. Such flexibility, such variety of vocabulary! Such a fine sound system! And we can look forward to its future changes. Performance and poetry, storytelling and fiction, are still alive and well. Orality and song stay with poetry as long as we are here.

Multiculturalism is generally conceived in synchronic terms: cultures and peoples of this historical time frame, in their differences. I'm suggesting we also be open to a diachronic view and extend our tolerance back in time. It would do no harm to take a sympathetic, open, and respectful attitude toward the peoples of the deep past. We can try to hear their language coming through paintings of lions and bison. This is now part of what our past will be.

Then we can also wonder through what images our voices will carry to the people 10,000 years hence—through the swirls of still-standing freeway off-ramps and on-ramps? Through the ruins of dams? For those future people will surely be there, listening for some faint call from us, when they are entering the sixtieth millennium.

10.

Lifetimes with Fire

■ ■ ■

IN 1968 I packed my books and robes, and with my young family I sailed back to California from ten years in Japan. When I first moved to a piece of Sierra mountain forest land the next summer, I wouldn't let even a tractor drive over it. Except for a couple of faint logging tracks that evolved into an access road, I wouldn't take a truck into the woods. We built a house that summer. We felled trees for posts and beams using an old Royal Chinook two-man falling saw and then barked the logs with large draw-knives. They were not skidded or trucked to the building site, but carried by crews of strong young men and women using rope slings and little oak pole yokes. The three-month job—the workers were mostly just out of college and only a few had architecture and building skills—was done entirely with hand tools. Our ridge had no grid power available and we had no generator. The rocky road ran across a barren mile of ancient rounded riverbed stone laid open by hydraulic mining in the 1870s. Beyond the diggings and three miles from the paved road deep in the pine forest was our building site. Town was twenty-five miles away across a twelve-hundred-foot-deep river canyon.

Twelve years later I took a trip back to Japan to visit Buddhist monk and artist friends. The Zen gardens and temples were lovely to see and smell again. Also I looked at the new farming and forestry. Small gas engines had taken over what oxen or humans had done before: ingenious tillers, small precise rice thrasher-huskers, a variety of weed-whackers, beautiful tiny trucks, brightly colored miniature backhoes

and excavators, and everyone using them without the least sign of guilt or stress. I thought, if the two- and four-stroke engine had a place even in the Asian scheme of things, maybe they'd work for me as well.

The roads have not improved yet, and there's still no grid power. Though I have stayed mostly with hand tools, over the years since we have gone from kerosene lamps to solar panels with a backup generator. I take my four-wheel pickup into the woods for firewood, and our homestead is now a hybrid of nineteenth- and twenty-first-century technologies. There's a wood-burning kitchen range and two large wood-burning heating stoves, but we also use laptop computers, have a fax and copying machine, and we buck the big down oak rounds with a large Husqvarna and a small Stihl chain saw.

Every summer season we did a bit more work clearing back the underbrush (ceanothus and manzanita) from under the trees, and every winter we burned the brush piles. California and southern Oregon forests are fire-adapted and are tuned to fairly regular low-level wildfires sweeping through. But then a few summers back it seemed the wildfires got hotter and the roads and houses closer together, and some big plans for firebreaks were designed by the California Division of Forestry.

I'd prefer to clear the understory fuel the natural way, with fire. I stood watch on a prescribed burn a few years back on Bureau of Land Management forest, with the planned burn zone overlapping onto an adjacent private parcel. It torched up a few big trees and burned a lot of underbrush down to ash. It was scary, but the fire chief assured us everything was okay. Bulldozer operators were on alert, ready to come if needed; and so were the CDF pilots at the county airport with their spotter and tanker planes. The burn went well all day. There were some complaints about the smoke. That's one problem with prescribed burns: the air quality goes down, and newcomers don't like it. But the bigger problem is that the site is getting brushy again eight years later. It needs a follow-up burn, and we don't know if we'll ever be able to do it. "The window of safety is too small." So maybe mechanical crunching is another answer.

In 1952 and '53 I worked on fire lookouts in the Skagit District of the

Mount Baker forest, northern Washington Cascades. Crater Mountain first and then Sourdough. Those were the first jobs I'd held that I felt had some virtue. Guarding against forest fires, finally I had found Right Occupation. I congratulated myself as I stood up there above the clouds memorizing various peaks and watersheds, for finding a job that didn't contribute to the Cold War and the wasteful modern economy. The joke's on me fifty years later as I learn how much the fire suppression ideology was wrong-headed and how it has contributed to our current problems.

I fought on a few fire-lines back in the fifties too—as I was working alternately in logging camps and on lookouts or trail crews. I'd be carrying the little backpack pump full of water with its trombone-slide pump, and always toting a Duff-hoe, which in California for some reason they call a "McLeod." Nowadays I have the yellow nomex jacket and a forest firefighter helmet. I found them both at the Salvation Army. Maybe a young firefighter just ran away. I am reminded that my roots are in the Pacific Northwest when California forestry people seem never to have heard of Filson tin pants and I'm the only one wearing White's boots from Spokane.

Fire in the very high mountains is most commonly caused by lightning. A lively lightning storm passes over, lasts all night, and hundreds of strikes are visible. Flashes light up the whole sky with their distant forks and prongs. Every once in a while a strike goes to ground, and even from a distance one might see a little fire blossom and bloom where it has started a spot fire, becoming a distant light that usually soon is quenched (storms coming with rains). A dry lightning storm is what's dangerous; you might have hundreds of spot fires going at the same time. A few of those are still going at dawn, and you take a reading on them with the Osborne fire-finder. You radio in the bearing and describe the drainage. Fifty years ago, the crews hiked in with the help of a pack string. Then there were only a few smoke jumpers.

In 1954 I was working as a choker-setter on a logging crew at the Warm Springs Indian Reservation in Oregon. A light plane crashed in the nearby hills and started a fire. They drafted a bunch of us off the crew and we hiked in, along with some Forest Service boys; half of

our logging crew was local Wasco and Warm Springs Indians. The fire had spread to about two acres, but the time was slow and the weather overcast and finally drizzly, so it wasn't hard to put it out. The pilot had been killed.

Fifty years later, I have three of those same backpack pumps, all in good condition, under the eaves near the toolshed door. They are filled with water and kept covered with cloth to protect them from the sun. A McLeod hangs on a bracket, and next to that in the wood-shed there's a whole section full of hoes, shovels, and a few extra fire rakes. The classic wildfire fighter's tool, a pulaski, hangs in the shop. In the open porch space of the house is a line of wood pegs holding work clothes, and one peg is reserved for firefighting clothes: ragged old Wild Ass logger jeans on a hanger, with the nomex fire coat and yellow helmet, and a full canteen looped on the peg as well. Wild Ass is a fetching label, a brand name from a logger supply company. They also make light blue boxer underwear, which for a while became de rigueur among some West Coast girls studying at Brown University. In one nomex coat pocket are firefighting goggles, and in the big pocket a pair of work gloves.

There are a several hundred families living in the pine-oak zone on this Sierra ridge. Higher up is national forest and heavy winter snow; lower down the blue oak, grass, and gray-pine country that once was hot and drouthy ranch land but now is either air-force base or becoming air-conditioned new development. At our higher forest elevation, most of the community seems to feel that we should be prepared to step out the door anytime to help hold the fire line until the Forestry crew trucks (men and women) come. There would be help from air tanker planes and backup bulldozers eventually, too, but if there are big fires going elsewhere in California, thousands of firefighters and all the equipment might be there instead. So then it's us and our small but dedicated volunteer fire department.

In the Yuba country's forested areas, there are plenty of firefighting protocols in place. The San Juan Ridge Volunteer Fire Department, the U.S. Forest Service, the Bureau of Land Management, the California Division of Forestry, and the local citizens with their Yuba Watershed

Institute. There have been several little fires that my family and I took care of ourselves. One time a tree only a few hundred feet from the house took a lightning strike, and the lower trunk and forest floor around were quietly burning. I saw the flickering light against the window. Three A.M. we went out and doused it with our backpack pumps, and went back to bed. At dawn we checked it again and doubled the width of the fire line.

Those of us who live in the actual wildland interface know and respect the public land agencies. But in the last decade some sort of white-flight semiretired population of right-wing suburbanites has also moved in to the lower elevations, many of them expecting all their neighbors to be like-minded. This faux-conservative ideology—I say "faux" because true conservatives believe in conservation—includes a habit of nasty attacks on the county land-use planners, animosity in principle against the Forest Service (and especially *biologists*!), and a deep distrust of the California Department of Foresty (CDF) because they require "logging plans" and might want you to clear more brush around your house for fire safety reasons even though it's "PRIVATE PROPERTY!" And some of them have convinced themselves that the Volunteer Fire Department is secretly run by former hippies. All is not bliss in the rural counties.

Back to fires: when there's suspicious smoke, the spotter plane takes off and cruises over, and if it's not just somebody's transgressive brush pile, tanker bombers might go out on it right away. If it looks needed, the bulldozer trailer hauler will start moving in that direction. CDF stations are staffed with crews all summer. They have admirable fire trucks, and they'll be there pronto. Still, in a place maybe twenty-five miles or more from a fire station, if there's a fire started, you're the one to hold it in check and maybe even put it out.

I had an education that pulled together a combination of labor in the woods and on the farm, seasonal U.S. Forest Service work, and a college major in Native North American ethnology, with a good dose of art, philosophy, and world history. My readings on native California cultures, and then doing backcountry trail-crew work for the Yosemite Park, helped me eventually realize that fire was not an enemy but could

be a partner. The huge Sierra Nevada range, from the timberline high country down to the oak and grass foothills, is all one big fire-adapted ecosystem, and a century of fire suppression has somewhat messed things up. I wrote the following poem in 1971:

CONTROL BURN

What the Indians
here
used to do, was,
to burn out the brush every year.
in the woods, up the gorges,
keeping the oak and the pine stands
tall and clear
with grasses
and kitkitdizze under them,
never enough fuel there
that a fire could crown.

Now, manzanita,
(a fine bush in its right)
crowds up under the new trees
mixed up with logging slash
and a fire can wipe out all.

Fire is an old story.
I would like,
with a sense of helpful order,
with respect for laws
of nature,
to help my land
with a burn. a hot clean
burn.
 (manzanita seeds will only open
 after a fire passes over
 or once passed through a bear)

And then
it would be more
like,
when it belonged to the Indians

Before.
> (from *Turtle Island*, 1974)

—nowadays they would call it a "prescribed burn" instead of "control"—and it's true you can't always control it. The "Indians" in this particular "here" were the Nisenan.

The Tahoe National Forest boundary is just a few miles east of where we live. From there and over the Sierra crest clear to Nevada is a checkerboard of public land and Sierra Pacific Industry lands, section by section. A 28,000-acre fire went through there in early fall 2001. Recovery and salvage logging* arguments have been divisive, and the Washington, D.C., Agriculture brass has been putting pressure on the Forestry Service line officers to cut more timber. Late summer 2002, from July to September, the "Biscuit Fire" in southwest Oregon swept over half a million acres, largely in the drainage of the lower Rogue. It got national coverage. Next came the always-contentious plans for salvage logging. The media fell into line, and much of the public has been sweet-talked into thinking cutting merchantable trees contributes to "forest health."

Three points: First, media reporting on wildfires is usually off the mark. It rarely tells us whether the fire is in brush, grass, or forest, and if in forest, what type. TV reporting might say "ten thousand acres were destroyed," when the truth is that fire intensity is highly variable and islands of green, patches of barely scorched trees, and totally scorched stands create what foresters might well call a healthy mosaic. A good percentage of Oregon's Biscuit fire was probably a good thing.

Two, as for the intensely burned areas, the outstanding forest ecologist Jerry Franklin had this to say in his "Comments" on the "Draft

* "Salvage logging" refers to the extraction of trees from stands killed or scorched by wildfire (not always dead), or by dead or dying beetle-kills.

Environmental Impact Statement" for the planned recovery project in the Rogue River National Forest's Biscuit Fire area:

> Salvage logging of large snags and down boles does not contribute to recovery of late-successional forest habitat; in fact, the only activity more antithetical to the recovery process would be removal of surviving green trees from burned sites. Large snags and logs of decay resistant species, such as Douglas-fir and cedars, are critical as early and late successional wildlife habitat as well as for sustaining key ecological processes associated with nutrient, hydrologic, and energy cycles.
>
> . . .
>
> Effectively none of the large snags and logs of decay-resistant species can be judged as being in excess of those needed for natural recovery to late-successional forest conditions. . . .
>
> . . .
>
> Slow re-establishment of forest cover is common following natural stand-replacement disturbances in the Pacific Northwest . . . This circumstance provides valuable habitat for early-successional species, particularly animals that require snags and logs and diverse plant resources, and for many ecosystem processes. Fifty years for natural re-establishment of forest cover is not a particularly long period; many 19th and early 20th century burns are still not fully reforested.
>
> . . .
>
> In fact, naturally disturbed habitat that is undergoing slow natural reforestation—without salvage or planting—is the rarest of the forest habitat conditions in the Pacific Northwest. Yet, it is increasingly evident from research, such as at Mount St. Helens, that such large, slowly reforesting disturbed areas are important hotspots of regional biodiversity.

20.I.04

This is bold and visionary science and contains the hope that both the Forest Service and the logging industry might learn to slow down and go more at the magisterial pace of the life of a forest. The bottom line for all talk of forest sustainability is holding to an undiminished quality of soil and the maintenance of the entire diverse array of wildlife species in full interaction. In earlier times, no matter what the bug-kills, fires, or blowdowns, the ecosystems slowly and peacefully adapted and recovered. After all, until recently the entire human project itself was a lot more leisurely and measured.

The third point, then, is we shouldn't use a forest fire's aftermath as a cover for further logging. What's called salvage logging should be prudent, honest, and quick. The "quick" part is difficult to achieve though, because the Forest Service has a miserable record of not being clear and aboveboard about its motivations and practices, and the skeptical environmental critics are always planning to sue the Forest Service. Almost any recovery plan tends to end up in court.

Here in the Sierra we live with the threat of fire six months of the year—miles of forest stretching in every direction from our small clearing. Over the last thirty-five years we've taken out the brushiest manzanita for several hundred yards, and thinned out a bit of the pine, oak, and madrone canopy. But any fire with enough wind behind it to crown could still overwhelm our little place—four outbuildings, a small barn converted to a seriously useful library and gear room, and a 1,700-square-foot handmade house—and hundreds of miles beyond.

I saw, and most of my neighbors saw, that our hand-clearing work was too slow, and that prescribed burns are also too slow and chancy. Even so it was a big step to let an excavator with the "brontosaurus" thrasher head go down our ridge through the oak and pine woods, crunching all the old-growth manzanita (leaving the pine and the oak), and spitting out wood shards everywhere, leaving big tracks in the duff. This for a fuel-break to help slow down a wildfire: not just for my place, but for all the forests to the north of me, on both private and public land.

Looking back on it later and recalling travels in the Chobe forest of Botswana in the early nineties, I can see it's not unlike the way the

Mopane groves look after a herd of elephants has browsed through, breaking limbs and thrashing the trees to get the leaves. Mother Nature allows for a bit of rough sex, it seems.

Our balance here with this mostly wild ecosystem is the same balance that we would hope for the whole North American West. We'd like to see the forests be a mix of mature and all-age trees cleared out or under-burned enough to be able to take the flames when they do come, and big and diverse enough to quickly recover from all but the very worst fires. This is doable—but it sickens one to see whatever clueless administration that is passing through use fear of fire to warp public policy in favor of more exploitation, more industry, and more restrictive law. It is an exact parallel of the use of "terrorism" to warp American values and circumvent our Constitution to justify aggressive foreign policy and to promote again the sick fantasy of a global American empire.

Fire can be a tool and a friend. I've always cooked on wood, outdoors and in. For several decades we had an open fire pit in the center of the house. The kitchen range was made in Saint Louis in 1910 with curvy floral Art Nouveau motifs. There's an outside kitchen area with a stone fire circle, forked sticks and cross bar, iron cook pots neatly hanging, and a wood-fired sauna bath from the Nippa company of Bruce Crossing, Michigan—last we heard, the only company still making wood-burning sauna stoves in North America. My sons and daughters learned kindling splitting, fire-laying, and feeding the stove as part of daily life.

Now that the fire pit is gone, the main heating stove is an Irish Waterford with a round stone watchtower (for Vikings) as its symbol, cast into a side panel. The other is a Danish Lange. Along one side it has a cast bas-relief of a stag with a crucifix between its antlers. The kitchen range: you start the fire going with some dry pine splits, then slip in dry oak to stabilize it and bring the heat up. If needed you can flash the heat up higher with more pine then slow it down with a chunk of green oak. Those are old kitchen cooking tips I learned orally from elders.

We use a short-handled hatchet, a graceful slender-handled Hudson

Bay axe, a full length poll axe, and a double bitted axe for specific tasks. For green wood bucking there is a Swede saw, a two-man saw, a small Stihl chain saw, and the big Husqvarna chain saw. For limbing the trees high up there are two pole-mounted pruning saws. For splitting, use the double-jack with a ten-pound head and a set of wedges. Also a twelve-pound maul. One needs at least five wedges for going at it: two for working a round from the top, and at least two more for opening it on the sides when it gets sticky. I've used hydraulic splitters too, and they are fast, but there's a lot of setup time. Every year we put five or six cords of oak and pine into the woodsheds, all of it from down and dead trees, and no sign of it ever running short. New trees grow, old trees drop, spring after spring.

The firebreak is in. Sixteen acres of forest and brushland were thinned and brushed, in a long skinny swathe, with some watershed improvement and firefighting funds helping pay the bill.

But there will always be brush piles, too. Year after year in the Sierra summer we work with axe and saw taking off limbs and knocking down manzanita, ceanothus, and too-dense pine, fir, or cedar saplings. We drag the limbs and little trees and pile them in an opening. When it gets to be fall, we scythe or Duff-hoe back the weeds around them, and make a mineral-earth fire line to be ready for winter burning. (Bailey's in Laytonville sells wide rolls of tough brown paper to put over your brush piles, and this will keep them dry through the first sprinkles of fall rain so that they'll light more easily. Since it's paper, you won't be burning the quickly shredding, black 4 mil plastic.)

You have to look for proper burning weather, just as with prescribed burns. Not too dry, not too windy, not too wet, not too hot. The very best is when you've had dry weather and can now see the rain clouds definitely coming. It has been a good burn day when the big pile burns to the ground and is still hot enough to keep burning up limb ends from around the edges when you throw them back. Then comes the rain, but still it all burns to ash. No further spreading or underground simmering can take place.

One late November day, standing by a twelve-foot-high burning

brush pile, well-dressed for it, gloves and goggles, face hot, sprinkles of rain starting to play on my helmet, old boots that I could risk to singe a bit on the embers. A thermos of coffee on a stump. Clouds darkening up from the west, a breeze, a Pacific storm headed this way. Let the flames finish their work—a few more limb-ends and stubs around the edge to clean up, a few more dumb thoughts and failed ideas to discard—I think—this has gone on for many lives!

How many times
have I thrown you
back on the fire

PART TWO

1.

With Wild Surmise

■ ■ ■

C ALL IT the Eastern Pacific, or the western edge of North
America; the East Pacific Rim—it reaches from the desert
mountains and *cardon* down in Baja up northwest past the
Mount Saint Elias range and beyond; Alaska and the Aleutian arc on
out to the Date Line. Into the mid-Pacific, the Hawaiʻian islands and
the further Pacific islands under temporary U.S. power. West of the
Great Basin: the Sierra/Cascade/rim of granite and volcanoes, and the
benign Pacific Slope with its westward rivers, forests and grasslands,
and summer mountain snowfields.

The salmon is the magical traveler that binds it together, weaving the
many threads of streams together with the deeps of the north Pacific.
Humpback whales that feed on herring in Sitka Sound will calve in
the warmer waters of Hawaiʻi. The albacore and tuna cruise south
through all the island realms.

Hawaiʻi is a remarkable human mix; and Alaska, too. Alaska still has
dozens of Russian Orthodox chapels, a memory of imported reindeer
herding experiments from Finland, Aleut fishermen who were interned
in Japan during World War II and who speak a little of that language,
and in the library a few books left from Russian times when there
was Aleut literacy—writing their language in a well-adapted Cyrillic
script. Fort Yukon was the farthest westward reach of the Hudson's Bay
Company. Russian fur traders pushing east came within a few hundred
miles in the same era. Texan oilmen work on the giant platforms that
go into the Chukchi Sea.

Meanwhile, in San Francisco, anybody can now get traditional Polynesian-style geometric tattoo designs (which are often seen among young Hawai'ian men—a sign of pride). The whole West Coast, with its ethnic and racial crossovers and its tolerance of difference, keeps on inventing a new trans-Pacific regional culture of backpacking, tea ceremony, varietal wines, animé movies, computer programming, zazen, organic vegetables, gridlock, and Burning Man.

We can look ahead to—East-Asian-Hispanic? Anglo-Raven Clan-Confucianists? We can only hope that the spirits of douglas fir, redwood, cedar, liveoak, manzanita, and especially salmon will guide us past gridlock and smog to a new culture of the Far West, and the vast Pacific.

<div style="text-align:center">

Living on the western edge of Turtle Island
In Shasta Nation,
Whose people are Native, Euro-, African-, Asian-,
Mestizo-, Pacific-, and
Nuevo-Americans
(Turtle Islanders);
Where the dominant language is Mericano.
In the Homo sapiens year 50,000

</div>

2.

Sustainability Means
Winning Hearts and Minds

■ ■ ■

I F SOCIETIES were incapable of surprising shifts and turns, if religions and philosophies, languages and clothing never changed, we'd surely have to grimly crunch away in the same old story, and eventually drown in some sort of Blade-Runner-type movie.

The oh-so-foolish deep ecologists, greens, eco-feminists, etc., are out there—at almost no cost to the system—providing imagination, vision, passion, a deeply felt ethical stance, and in many cases some living examples of practice.

I have no quarrel with restoring creeks, crunching understory fuel load, doing a pre-commercial thinning, logging out genuinely sick trees, hanging out counting the frogs in the creek, taping owl calls, piling up data in the workstation and all that. I do it myself. If it's done with the commodity mind, you might as well be managing a detention camp. If it's done with the mind of the natural neighborhood, with the intimacy that comes with knowing yourself as a member of the ecosystem, then those very same chores are a matter of working with and learning from the nonhuman critters in the 'hood. It becomes a collaboration, a feast, a memorial gathering, a ceremony. This is what deep ecology is about. The ethics of concern for all beings including the nonhuman, incidentally, are not just some invention of "new agers," Norwegian philosophers, or Native American academicians, but are anciently and deeply rooted worldwide, going back for millenia. Buddhism and much of Hinduism put this ethic at the top of their list of precepts.

I believe that more people staying put, learning their place, and taking on some active role would improve our social and ecological life. I have said that people should try to become "*paysan, paisanos, péons*" in the meaning—people of the land—people of the place. But note: there's no limit to how big the place can be. The size of the place that one becomes a member of is limited only by the size of one's heart. We speak of watershed consciousness, and the great water-cycle of the planet makes it all one watershed. We are all natives to this earth.

Yet one has to start where one is and become nature-literate to the scale of the immediate home place. With home-based knowledge, it is then within our power to get a glimpse of the whole planet as home. As a rule though, local knowledge (combined with an understanding of the dynamics of systems) remains the most useful, and the most delicious.

No one ever said that the old bioregional slogan "don't move" means you can't go on trips, either. Peasants of ancient Japan, religious devotees of India, have always gone on long pilgrimages to temples and caves in the mountains or along the rivers after harvest was over. Even when on a trip, you are always clear as to where you came from. We can be thankful that bioregional practice is more sophisticated than some replay of the medieval village. Since it is a line of thought for the future, it calls us to be ecologically and culturally cosmopolitan, hip to the plant and weather zones of the whole world, as well as to those of cuisine and architecture.

As for technology: smarter bombs, faster computers, quieter chain saws certainly have their place. The struggle for the integrity of the environment will need good tools—the good guys want their computers to be as big and fast as those of the bad guys. Understandably. But though weapons win battles they don't win the peace. Peace is won by winning hearts and minds. Watershed imagining, bioregional ideas of governance, the actual existence of communities that include the nonhuman in their embrace, dreams of ecological justice, and the faint possibility of a long-term sustainable land and culture—all this nutty ancient stuff is a matter of engaging hearts and minds.

3.

"Can Poetry Change the World?"

■ ■ ■

SUSAN DENNING: What is the most satisfying thing for you about writing, and has that changed over the years?

GARY SNYDER: The act of making something, bringing elements together and creating a new thing with craft and wit hidden in it, is a great pleasure. It's not the only sort of pleasure, but it is challenging and satisfying, and not unlike other sorts of creating and building. In Greek "poema" means "makings." It doesn't change with the years, or with the centuries.

SD: How do you know when a poem is finished?

GS: It tastes done.

SD: If animals wrote things down, who would you rather hear a poem by—a raccoon or a possum?

GS: A raccoon's poem is alert and inquisitive, and amazes you by what a mess it makes. A possum's poem seems sort of slow and dumb at first, but then it rolls over. When you get close to it, it spits in your eye.

SD: What's the most striking difference to you between California wilderness and Oregon wilderness?

Interview with Susan Denning in *Caffeine Destiny* (online zine, 2001).

GS: You need to specify east side or west side, north or south, for this to be a useful question. The northwestern California–southwestern Oregon zone is basically one. Southeast Oregon belongs with the Great Basin and then a lot of eastern Oregon to the Columbia Plateau. Lower Columbia includes both sides of the river. The differences, east or west, are expressed basically in precipitation. And the northern spotted owl needs bigger and denser groves than the southern.

SD: Do you find yourself working on several poems at once, or do you start one poem and see it through to some kind of conclusion before you start on another one?

GS: Both, and also other strategies and variations as well. An artist is a total switch-hitter.

SD: Are there some poets whose work you return to again and again?

GS: Yes, among them Du Fu, Lorca, Bashô, Pound, Yeats, Buson, Bai Ju-yi, Li He, Su Shih, Homer, Mira Bhai, Kalidasa.

SD: What is your advice to writers who are just starting out?

GS: Think like a craftsperson, learn your materials, your tools, and then read a lot of poetry so you don't keep inventing wheels.

SD: Scientists predict the Columbia River will be radioactive in 20–30 years, if not sooner, due to Hanford leakage. Do you see this situation as irreversibly hopeless?

GS: I don't have enough information on it to judge.

SD: Can poetry change the world?

GS: Ha!

4.

Three Way Tavern

■ ■ ■

O<small>NE AFTERNOON</small> in the late 1990s, Ko Un and I read poems
together to a small audience in Northern California. Friends
had gotten us together, of an age to be brothers and each
with a quirky take on the world, living on opposite sides of the big
ocean. I read his poems in English with a bold out-loud voice and
then he read them in Korean, his voice almost a whisper, sharpening
people's ears and making us all alert. His otherworldly voice made
the poems even more powerful. That was my first lesson, of many,
from Ko Un.

Korea is the less-known country between China and Japan that par-
takes of both cultures and does their high styles extremely well, but
also keeps its own archaic heritage with all its difference: stubborn and
strong, proud, elegant, gritty, bold, and deeply conservative. A people
descended from the Bear-mother (who gave birth to King Tan'gun);
a high civilization where women shamans play a role in religious life.
In the Buddhist mountain monasteries, nominally Son (or, in Japa-
nese, Zen), they still engage with the "Flower Wreath Sutra," Queen of
Sutras, almost forgotten everywhere else in the world. Ko Un retold in
Korean a chunk of this sutra known as *Hua Yen* in Chinese, *Kegon* in
Japanese, *Hwaom* in Korean, and it became a best-seller. Korea honors
a Confucian practice older and purer than whatever is left in China
or Japan. There are lots of zealous Christian converts and plenty of

Foreword to *The Three Way Tavern,* by Ko Un (University of California Press, 2006).

well-read socialists and unionists in Korea. And there's always a crew of hard-drinking politicians (as well as poets and artists), and sharpie-dressed women. Korea has great food (not too hot at all) and restaurants, each with its own crock of rice-beer bubbling, and giant vats of various types of kimchee pickles that bubble too.

The traditional poems of China and Japan are not so similar; Korea's poetry too has qualities all its own. The languages each have their own specifics, and the writing systems, though related, are now far apart. Ko Un's poetry in modern Korean is more different yet, though still clearly within the East Asian mold. Because of their purity, their nervy clarity, and their heart of compassion, his poems are not only "Korean"— they belong to the world.

This book is a selection from the many volumes of poems Ko Un has written—out of day's work and human turmoil and delight in the countless little towns and farms on Planet Earth. Ko Un's poems evoke the open creativity and fluidity of nature, and the funny turns and twists of Mind. Mind is sometimes registered in Buddhist terms— Buddhist practice being part of Ko Un's background. Ko Un writes spare, short-line lyrics direct to the point, but often intricate in both wit and meaning. There are also a few long poetic meditations. He writes particular poems of people's lives: one of his projects is to do ten thousand poems for ten thousand different persons; some of those are gathered here.

I savor his play between the Pure Land (a Buddhist vision) in the poem "Hometown":

> If you go back before you were a human, that's where your
> 　　home is.
> No, not even there, go back further.
> Just try yelling without yearning
> in the simple voice of an animal
> what the beast returns to,
> the pure land, that's home.

and the—what shall I call it?—"Toxic Land," a modern vision, a trick-
ster "pure land," in the poem "Back Home":

> I came back
> to where trash
> blooms like flowers
> —this is the world I longed for.

There's a poem called "Letters" that tells of a day in grade school
during the Pacific War and the teacher asking the children what or who
they would like to be. Ko Un responded, "The Emperor" (of Japan).
This was a great scandal, and after being banned three months from
school, he was asked the question again. He said, "A mailman":

> I wanted to be a man who delivers messages from one man
> to another.
> I loved the mailman and the mail.
> When the mail bike showed up, I closed my books and
> trotted after it
> though no letters came for me.
> Twenty pieces of mail are all the village gets a year.

A lot of the American interest in Ko Un came through the buzz of
Zen (*Son*) and his 1997 booklet *Beyond Self*, with a fine foreword writ-
ten by Allen Ginsberg. Some of those small verses are included here,
in the section from *Ko Un's Son Poems: What?*, and they are koan-like
kernels of deep dharma wit. Yet he is not simply a Zen poet. His earlier
book *The Sound of My Waves* (1993) has many poems of daily people's
country and small town life, hands- and feet-on. It is a further chal-
lenge to get to know this post-Zen side of Ko Un and his later complexly
situated, totally contemporary poetic view.

Ko Un has lived through many of the lives his poems embody.
Peasant village boy, bright student, army conscript, Son monk for
ten years, schoolteacher, writer, published convivial poet-drinker,
political activist for greater South Korean democracy, fiction writer,

political prisoner, family man, and major public cultural figure—there's even a movie made from his epic based on the "Flower Wreath Sutra": *Little Pilgrim!*

Our totem fish and indicator species for the whole North Pacific Rim, around the Aleutian chain from Korea to the Big Sur River, is salmon. So then, what about a rowdy peasant marriage festival:

SALMON

So sleek and so handsome
she swam away to a distant sea,
with a normal gray back, and
a silvery white belly,
lived four glorious years in the sea.

Empty body without food.
Beautiful body,
the head swells,
its mouth hooks,
ugly as can be,
red dots swarming her.

I can't look at
her ugliness.
When the ugly woman
heads straight home
the world lights up.
From far away
you can hear the party drums beat.

Even though he stays specific with mustard flowers and barley, with names of hills and provinces, Ko Un has now traveled worldwide and is not only a major spokesperson for all of Korean culture, but a voice for Planet Earth Watershed as well.

5.

The Will of Wild Wild Women

■ ■ ■

ALTHOUGH JAPAN is supposedly a patriarchy, it has an emperor whose first spiritual obligation is to his ancestress the great Goddess of the Sun, Amaterasu. Once a year, we are told, he has a solitary ritual meal with her in a remote chamber at the Great Shrine of Ise. The moon, in Japanese mythology, is masculine, not feminine. The earliest Chinese references to Japan—before Japan even had a writing system of its own—describe it as a land of tribes led by "Queen Pimiko." The Chinese sources even then described these offshore island people as loving music and drink, and said their religious leaders were women shamans. The Sun Goddess, in a pivotal early myth, is brought out of her retreat to a cave by the almost-naked dance of a rowdy Goddess named Ame-no-Uzume and the uproarious laughter of the surrounding gods.

Japan has a rich store of traditional folktales, *mukashibanashi*, "tales of long ago." These have been made available for the modern Japanese reader in the exhaustive collections and scholarship of great folklorists like Kunio Yanagita and Keigo Seki. Japanese folktales prove to be very much part of the worldwide body of folklore, with motifs that we instantly recognize, coming to them through our own acquaintance with, say, the Grimm collection, or an Indian anthology like the *Pañca Tantra*. The similarities, and the differences, in these perennial stories of morals and magic elicit endless study and speculation.

Foreword to *The Japanese Psyche: Major Motifs in the Fairy Tales of Japan*, by Hayao Kawai (Spring Press, 1996).

All world folklore has powerful female figures, but Japan is exceptionally rich in this regard. Magical maidens who are super-sensitive birds, sweet old ladies who turn out to be cannibals, all-devouring brides, mountain hags who admire human dancers, and many more.

Carl Jung and his circle found world folklore and mythology to be a source of insight into the deepest human mind. They developed a method of analysis that teases out ways of identifying the elements, the dynamics, of the soul. Hayao Kawai, a Japanese Jungian, breaks new ground in applying these methods. Referring to the work of James Hillman and Erich Neumann in particular, he finds distinctive twists in the Japanese stories, and thereby adds to our understanding of the cultural personality. He argues that ". . . psychologically, we can say that the eyes by which Japanese look at the world are located in the unconscious depths rather than in the conscious." And he concludes that "the female figure best expresses the Japanese ego." He comments on the strength of the father–daughter tie in Japan, saying that in the Occident the father–son relation is paramount. And in countless ways throughout the book he points out the strength and diversity of the female image, saying, "The various types of women appearing throughout should be recognized as always changing positions, not as developmental stages. These protean female figures express the Japanese mind: multiple layers creating a beautiful totality."

This is rich stuff. But as if that weren't enough, he takes on the question of deity. In the Occident of recent centuries everything has been defined in the light of a dominating male deity. The equivalent force in East Asia, Kawai says, is "Nothingness." An unsuspecting American reader may well ask how he got there. The credentials for this argument, if obscure to some, are nonetheless credible. The early Taoist writings of Lao-tzu and Chuang-tzu, fifth to third century B.C., in witty and skillful metaphors propose the depth, utility, and spiritual power of what they call Nothingness. Buddhist thought from India, coming along a little later, based much of its practice on a rich and creative idea of "emptiness," defined as meaning nonsubstantiality, absence of self, interconnectedness, potentiality, and the practice of

nonattachment. This philosophical stance is at the core of almost all of Mahayana Buddhism. In contemporary Japan, the philosophy of Nothingness has a strong and much-respected secular presentation in the works of the Kyoto school of philosophy founded by Dr. Keitaro Nishida.

At the risk of giving away too much, I would like to show a little of how this aspect of the story proceeds:

A woodcutter takes a lovely day when he is feeling wonderful to simply go for a walk in the forest. He stumbles into a mansion, is greeted by a beautiful woman who accepts his promise not to look about, and is left to guard the house while *she* goes for a walk. He breaks his promise and enters succeeding rooms to find elegant young women who then disappear; finally he discovers—only to drop and break—three little bird-eggs, which turn into bush warblers and fly off. The mistress returns, finds him in this state, sadly admonishes him, and turns into a bird herself and flies off. He finds himself standing alone in an empty forest clearing.

The woodcutter then chooses to retreat deeper into the forest and to live alone as a lowly charcoal-burner, making himself nothing, a kind of penance for his transgression, and thus becomes like the character known as Goro, in another story.

In that other story, a strong-hearted young woman who has walked out on her foolish and arrogant new husband on account of his disrespect toward the spirit realm comes onto Goro's hut. She asks shelter, and though he says his hut is too modest for her, she insists. Then she directly asks Goro to marry her, and though he at first refuses, she again insists. After they have married, they discover their charcoal kilns to be full of gold.

As a parable of the heart, Kawai suggests, the courageous young woman is no other than the woman who flew off and left the woodcutter for his transgressions. Her strong will, her sense of self and purpose, has enabled her to keep clear of wrong entanglements, and she finds her way to the woodcutter (now Goro) as he first found his way to her, and now they are both ready for each other.

This is a model from the deep tradition to propose for the present:

a model which holds that when a man is able to be "nothing" (as was Cabeza de Vaca, in an entirely different, but marvelously related story), a marriage is possible. The potentiality inherent in "Nothingness" can then join with spiritual energy (here seen as feminine); a marriage that generates endless blessings for everyone.

The "woman of will" who comes out of a deep corner of the Japanese psyche is indeed a great model for the present. Remembering that in the language of the soul the terms "woman" or "man" do not refer to sexual characteristics but to key positions of being, we can all hope to develop our capacities as "women of will" and as "men of Nothingness." And gold, let us recall, does not refer to that metal whose price fluctuates in Zurich, but to a wealth of wisdom and compassion that can only increase if it is given away.

Hayao Kawai's book is full of wonderful turns. Japanese folktales have specific and charming qualities of their own (as all folktales do) so that one is never dealing simply with familiar counters in the game of motif analysis. Mr. Kawai's take on it is fresh and ingenious. Possible conclusion: take your daughter to work day.

6.

Coyote Makes Things Hard

■ ■ ■

How, I wonder—how, I wonder—
in what place, I wonder—
where, I wonder—
In what sort of place might we two see a bit of land?

THERE MIGHT be a place of land. It would have a snow mountain to the north, a blue-grey expanse to the east, ridges and canyons to the south, and a broad valley to the west that leads to further mountains and finally to the edge of the world. This land might have great meadows, beautiful parklands, bare granite ridges, and splendid fast streams and rivers. It might be someone's home.

It *was* someone's home, for tens of thousands of years. They were *maydy,* "creatures," "beings" of thousands of sorts, which included *wonom maydy,* "human creatures." These "maidu," human beings of the running ridges, deeply forested canyons, and mountain meadowlands of the northern California Sierra, tell a wonderful set of tales about their fellow creatures and their place. They tell it from the beginning.

This collection opens with an outstanding creation myth. It was told to turn-of-the-century anthropologist Roland Dixon by a renowned storyteller named Hánc'ibyjim, "Tom Young." His language was Northeastern Maidu. In the early fifties a young linguistic

Foreword to *The Maidu Indian Myths and Stories of Hánc'ibyjim,* by William Shipley (Heydey, 1991).

anthropologist named William Shipley took up Maidu studies with an elderly woman named Dículto, Lena Thomas Benner. Her daughter Maym Benner Gallagher and Shipley went over Dixon's texts again, to come up with what is surely one of the richest sets of old-time Turtle Island texts available.

At the beginning it seems there were two sacred characters running around together, arguing, planning, constructing, taking apart, disagreeing, and making a universe. K'ódojape and Wépam wájsy, Earthmaker and Coyote Old Man, they quarrel like lovers—but there's a little bit more to it than just kvetching between friends.

> *Wanting a bit of land*
> *imagining it to be somewhere*
> *singing it into being*

And the two find a little bit of land floating, stretch it, form it, visualizing what it could become. Then these two sacred goofy buddies come up with the idea of "many creatures" and specific habitat for each. They pick a "little creature" out of somewhere, and make a plan that when this little guy gets big enough, the he's and she's will have names for things and they'll have a "country." These are the humans.

And there are songs. Earthmaker gives them to all beings:

> *There will be songs—*
> *there will always be songs,*
> *and all of you will have them.*

Coyote is no stranger, now, to the twentieth-century Euro-American imagination. There are several widely differing interpretations of what he might be. He is seen as a sort of rock musician shaman, or as a culture-hero/trickster, who holds contradictory powers and plays a role that is sometimes creative and sometimes destructive, or an archetype of the immature unsocialized ego, or a perennial witty

amoral survivor; sometimes he is even the outright principle of evil, the devil.

Coyote is a big presence in this collection, in every sense, and it is worth looking closely at the role he plays in "creating/defining" the present world. It will not ruin the story that lies ahead to say a little about it. These two characters who are forming (or defining) the world are not, I am sure, representing good and evil principles slugging it out inconclusively. They step together through a dialectic, a dialog, of ideal and real, with a sinewy final resolution that takes the world as it is. Even as Earthmaker hopes for a universe without pain and death, Coyote argues for impermanence, for things as they *are*. As Earthmaker fantasizes a world in which unmarried girls remain virgins and married couples remain celibate, Coyote calls for tickling, lovemaking, and whispering to each other. Earthmaker has a plan for immortality; Coyote insists that there be death. Coyote wins out, and Earthmaker wanders off, to remain in isolation somewhere "down below." Coyote goes on to finish defining the world that is our present reality. Earthmaker proposes an ideal; Coyote presents the phenomenal. For a spell Earthmaker and Coyote shape the world almost as partners. And finally, Coyote attends to a world totally phenomenal, yet one that is fluid, shape-shifting, role-playing, painful and dirty, but also cheerfully transcended. If Coyote stands up for *samsara*, the actuality of birth-and-death, it is part of the ultimate paradox that he cannot be killed. He always pulls his scattered conditional self together again and goes trotting on. In the ongoing tales of Old Man Coyote, we see what could be called "jokes of *samsara*" played out: outrageous, offensive, and ultimately liberating—into rueful acceptance, courage, and humor.

There are tales of other beings too. What realities are echoed! When the Cottontail boys tease Woodrat, "Old Woodrat makes me puke! Shitting on his grandmother's blankets—stinking everything up— pissing on everything—yucky old Woodrat! Makes his whole house stink!" we are getting an angle on the several-millennia-old wood rat

middens found preserved in caves or overhangs in the Great Basin, containing solidified urine and antique fecal pellets at the ancient twig bottoms. These are useful for radiocarbon dating, and for pushing the dating-scale farther back.

Perhaps we have heard too much of Coyote. There are would-be coyotes hanging out all over the western United States. He has overshadowed the other figures of western North American oral literature. This is partly because he has not been kept "secret." There are narratives that were never trapped in writing and are not told to outsiders that might balance this emphasis. The story of Mountain Lion and his long search for his lost children is of a different realm, unfolding in real time. Moon is a compulsive child-kidnapper, and it takes the persistent old woman Frog to set him straight (even though she can't quite manage to swallow him). Also there are dramatic moments in these tales as old as any telling, that make them part of that truly ancient international lore that underlies the later "world classics." We are drawn into the aura of the giant serpent who would love a human girl, raising his great head and staring intently in her eyes, night after night. We have known the teenage girls who danced and talked and dreamed of having stars for lovers, and then got them and *that* was trouble. We gingerly feel our way into

> Moon was living with his sister
> Their house was coated with ice.

The world of Native American myths and tales is not exactly pleasant. Captured wives, stolen children, hard-dealt death. Some would say that we should be grateful to Coyote for making things challenging. Coyotes are still around, the stories are still vivid, and the People are still here, too. The relatives of Hánc'ibyjim and Maym Gallagher are alive and well, keeping their culture alive, and playing a strong role in the future of their bioregion.

These myths and tales are unsweetened, unsentimental, and irreducible. They are a profound little chunk of world literature, and they are the first, but not the last, stories to be told of where we are learning to live: the little watershed of northern California, the big watershed of the planet.

7.

Shell Game

■ ■ ■

JERRY MARTIEN tells a rich story. He went back east, three thousand miles overland, from his home at the western edge of North America, without much money. He went to revisit his past and pursue an obsession. The wry tale of his own loves and losses, and the backpack of scholarly books that walks the night streets with him, is stitched into this study of misunderstanding, loss, and also persistence of a way of life based on reciprocity. His tale starts with beads.

Seashells. Clams and conches, bivalves and univalves. A hard white surface secreted line by line from an edge of the soft mantle, using precious molecules of calcium sucked in from the sea. Protects soft flesh, and then the shell lives on for years. Durable, smooth, hard, pale or purple or pink, ground and polished, drilled for beads. Beads in strings or belts or necklaces make us look and feel special, and became bonds and tokens, even (Martien suggests) "messages" in a virtual language of gift and agreement. They were a key item in the ancient gift economy and its exchanges of love, land, condolences, spirit, art, resistance. We learn that the earliest metal coins, from Tyre, had a seashell on one side, and a dolphin on the other.

Folded into Martien's account is his research on the history and complex logic of wampum (shell bead strings or belts) as used by the highly organized native nations of what is now New York and

Foreword to *Shell Game: A True Account of Beads and Money in North America*, by Jerry Martien (Mercury House, 1996).

New England, the peoples of the Longhouse. The Dutch, English, and French traders and settlers apparently failed to grasp that wampum, with its many ceremonial and political uses, was not just an Indian equivalent of money. This added a peculiar semantic confusion to the already perplexing and depressing story of the slow and steady expropriation of native lands even prior to the existence of the United States. American history has been "centuries of denial" of deliberate lying, cheating, and massacres. "This is how the New World was 'conquered,'" Martien says, "not with a bang, but one crooked deal at a time."

The Iroquois and their neighbors were a remarkably productive, gifted, socially sophisticated, and sizeable population that played a significant role in the early Euro-American economy. In the end what they got was scorn and pain. And Martien suggests that the economic rationale of the early Atlantic traders (many of whom believed that it was not merely profitable but *virtuous* to commodify the world) has finally tricked and cheated us all. We live in a blighted social and ecological landscape, most people increasingly confined to the poverty of the national reservation.

The Shell Game's special contribution is as a meditation on history, economy, and the human heart. Martien draws on the seminal work by the anthropological economist Marcel Mauss, "Essay on the Gift" (*Essai sur le Don*), and Lewis Hyde's useful extension of that called *The Gift*. He reminds us that although the old gift exchange modes may have expired, they still offer insights for social, spiritual, and moral life.

Martien's narrative brings him back to the northern California Pacific Coast to note there too the power of dentalia shell and abalone beads among the Native Californians, and he sums up his lessons: stewardship, restoration, generosity, and "investment in longer-term bonds." These bonds are for "communities where kinship means both family and place, and for watersheds where salmon [or forests, or grasslands, or well-tended orchards] are the primary indicator of riches." In our families and communities, friendships and crafts, at

least, we can do this. *The Shell Game* itself is a gift. And this foreword is a small return for poems of Jerry's that touched me long ago, as well as an expression of appreciation for the present text. We must hold some space open for a path with heart.

8.

"The Way of Poisons"

■ ■ ■

T HIS IS A BOOK about plants. Green, sweet, peaceful plants:
the harmless beings who give us flowers, nuts, fruits, roots,
sap, bark, fiber, and shade. But some aren't so great to eat—
sour, bitter, or worse. Plants are all chemists, tirelessly assembling the
molecules of the world, and in their transactions with insects, birds,
animals, and fungi, they find elaborate ways to defend themselves, to
seduce pollinators, to confuse. In looking at the interplay of plants,
insects, animals, and humans, the author suggests how toxins shaped
ecological systems. How much we assume about plants and how little
we know them! Dale Pendell playfully says, "Only plants had con-
sciousness. Animals got it from them."

Here are people, the plant-women and men, who for millennia
investigated the properties of plants and learned to use them for heal-
ing, for their effects on the mind, for poisons. These ancient experts
and traditional professionals knew and kept plant secrets close for
generations.

In recent centuries those who knew plants and their powers have
often been stigmatized, as though danger and unpredictability were
of themselves evil. Human cultures that demonize death or pain or
sickness are thus less able to deal with the bitter side of nature, with
intoxications; and they make themselves doubly sick.

The Buddha taught that all life is suffering. We might also say that

Foreword to *Pharmako/Poeia* by Dale Pendell (Mercury House, 1995).

life, being both attractive and constantly dangerous, is intoxicating and ultimately toxic. Cupid shoots an arrow that strikes and changes you forever; love is toxic. "Toxic" comes from *toxicon*, Pendell tells us, with a root meaning of "a poisoned arrow." All organic life is struck by the arrows of real and psychic poisons. This is understood by any true, that is to say not self-deluding, spiritual path.

So Pendell speaks of the "way of poisons." This way (modern and ancient shamanism and herbcraft verging into ethnobotany and ethnopharmacology) has developed a remarkable body of empirical and scientific knowledge to place against current "official" ignorance and resistance to the possibility of clear and courageous thinking about the many realms of drugs.

This is a book about danger: dangerous knowledge, even more dangerous ignorance, and dangerous temptations by the seductions of addictions both psychic and cellular. One must not be titillated by ideas of self-destruction. I believe pharmakopoeia will benefit human beings and the plant world too. It is not for everyone—but neither is mountaineering.

Pendell quotes William Blake, "poets are of the devil's party." Poets, needless to say, are not satanists, so what does Blake mean? I think he is saying that for those who are willing to explore the fullness of their imagination—mind and senses fully engaged—there are great risks, at the very least, of massive silliness. Farther out is madness. No joke. But forget about the devil: poets and such travelers also bring a certain sanity back home. Here is a look at half-understood truths and serious territories of remaining mystery.

Industrial toxins and wastes are in the air and oceans, and buried and heaped up on the land. Our very food now seems suspect. "Better living through chemistry" was brought us by our own entrepreneurial and arbitrarily regulatory societies. The developed world now has to work all these questions out with vast environmental destruction at stake. Who indeed are the crazies of the twentieth century? We desperately need to understand the basics of plants, of consciousness, of poisons. Pendell offers us a tentative map with scribbled reports by scouts from the territory beyond the ranges, and it aims for sanity.

9.

Regarding "Smokey the Bear Sutra"

■ ■ ■

WHEN THE Wild gave the U.S. Forest Service the gift of the Sacred Cub some years back, the Agency failed to understand the depth of its responsibility. It did not seek to comprehend who this little messenger was, and instead the young bear was reduced to a mere anti-forest fire icon and manipulated in its one-sided and foolish campaign against wildfire. Now it is time for the truth to come out. "Smokey Bear" brought a rich and complex teaching of Non-Dualism that proclaimed the power and the truth of the Two Sides of Wildfire. This was the inevitable resurfacing of our ancient Benefactor as Guide and Teacher in the new millennium. The Agency never guessed that it was serving as a vehicle for the magical reemergence of the teachings and ceremonies of the Great Bear.

As one might expect, the Great Bear's true role of teaching and enlightening through the practice and examination of both the creative and destructive sides of Fire was not evident at first. As with so much else in regard to the Forest Service, it was for the ordinary people, trail crew workers and fire line firefighters, to expose the deeper truths. On fire lines and lookouts in the remote mountains, through deep conversations all night among the backcountry men and women workers, it came to be seen that the Great Bear was no other than that Auspicious Being described in Archaic Texts as having taught in the unimaginably distant past, the one referred to as "The Ancient One." This was the Buddha, who only delivered her teachings to mountain

and river spirits, wild creatures, storm gods, whale ascetics, bison philosophers, and a few lost human stragglers.

It will take this sort of Teaching to quell the fires of greed and war and to guide us in how to stave off the biological holocaust that the twenty-first century may prove to be. The return of the Ancient Wild Teachings! The little Cub that restored our relationship with that Old Inspirer! What marvels!

We can start enacting these newly rediscovered truths by making fires, storms, and floods our friends rather than our enemies, and by choosing for wise restraint and humorous balance on behalf of all.

A sutra is a talk given by a Buddha-teacher. The Smokey sutra first appeared on Turtle Island, North America. Like all sutras, it is anonymous and free.

SMOKEY THE BEAR SUTRA

Once in the Jurassic, about 150 million years ago,
the Great Sun Buddha in this corner of the Infinite
Void gave a great Discourse to all the assembled elements
and energies: to the standing beings, the walking beings,
the flying beings, and the sitting beings
— even grasses, to the number of thirteen billion, each one
 born from a
seed, assembled there: a Discourse concerning
Enlightenment on the planet Earth.

"In some future time, there will be a continent called
America. It will have great centers of power called such as
Pyramid Lake, Walden Pond, Mt. Rainier, Big Sur,
Everglades, and so forth; and powerful nerves and channels
such as Colombia River, Mississippi River, and Grand Canyon.
The human race in that era will get into troubles all over
its head, and practically wreck everything in spite of its own
strong intelligent Buddha-nature."

"The twisting strata of the great mountains and the pulsings
of great volcanoes are my love burning deep in the earth.
My obstinate compassion is schist and basalt and
granite, to be mountains, to bring down the rain. In that
future American Era I shall enter a new form: to cure
the world of loveless knowledge that seeks with blind hunger;
and mindless rage eating food that will not fill it."

And he showed himself in his true form of

SMOKEY THE BEAR.

A handsome smokey-colored brown bear standing on his
hind legs, showing that he is aroused and watchful.

Bearing in his right paw the Shovel that digs to the
truth beneath appearances; cuts the root of useless attachments,
and flings damp sand on the fires of greed and war;

His left paw in the Mudra of Comradely Display—
indicating that all creatures have the full right to live to their limits
and that deer, rabbits, chipmunks, snakes, dandelions,
and lizards all grow in the realm of the Dharma;

Wearing the blue work overalls symbolic of slaves and
laborers, the countless men oppressed by a civilization
that claims to save but only destroys;

Wearing the broad-brimmed hat of the West, symbolic of
the forces that guard the Wilderness, which is the Natural
State of the Dharma and the True Path of man on earth;
all true paths lead through mountains—

With a halo of smoke and flame behind, the forest fires
of the kali-yuga, fires caused by the stupidity of those
who think things can be gained and lost whereas in truth all is
contained vast and free in the Blue Sky and Green Earth
of One Mind;

Round-bellied to show his kind nature and that the great
Earth has food enough for everyone who loves her and trusts
her;

Trampling underfoot wasteful freeways and needless
suburbs; smashing the worms of capitalism and totalitarianism;

Indicating the Task: his followers, becoming free of cars,
houses, canned food, universities, and shoes, master the
Three Mysteries of their own Body, Speech, and Mind; and
fearlessly chop down the rotten trees and prune out the sick
limbs of this country America and then burn the leftover
trash.

Wrathful but Calm, Austere but Comic, Smokey the Bear will
Illuminate those who would help him; but for those who would
hinder or slander him,

HE WILL PUT THEM OUT.

Thus his great Mantra:

Namah samanta vajranam chanda maharoshana
Sphataya hum traka ham mam

"I DEDICATE MYSELF TO THE UNIVERSAL DIAMOND
BE THIS RAGING FURY DESTROYED."

And he will protect those who love woods and rivers,
 Gods and animals,
hobos and madmen, prisoners and sick people,
musicians, playful women, and hopeful children;

And if anyone is threatened by advertising, air pollution,
or the police, they should chant SMOKEY THE BEAR'S WAR SPELL:

 DROWN THEIR BUTTS
 CRUSH THEIR BUTTS
 DROWN THEIR BUTTS
 CRUSH THEIR BUTTS

And SMOKEY THE BEAR will surely appear to put the enemy
 out
with his vajra-shovel.

Now those who recite this Sutra and then try to put it in
 practice will accumulate merit as countless as the sands
 of Arizona and Nevada,
Will help save the planet Earth from total oil slick,
Will enter the age of harmony of man and nature,
Will win the tender love and caresses of men, women, and
 beasts,
Will always have ripe blackberries to eat and a sunny spot
 under a pine tree to sit at,

AND IN THE END WILL WIN HIGHEST PERFECT ENLIGHTENMENT.

 thus have we heard.

(Yuba River redaction.)

10.

On the Problems Lurking in the Phrase "Before the Wilderness"

■ ■ ■

SINCE KAT ANDERSON and Thomas Blackburn's volume *Before the Wilderness: Environmental Management by Native Californians* (Ballena, 1993) came out, there has been a fascinating and somewhat unreflective response to the implications of the title itself. Anderson and Blackburn's book is a collection of papers whose total effect is groundbreaking in documenting the many intelligent and deliberate ways indigenous Californians—*as foragers*—shaped and altered immediate landscapes. It makes a significant contribution to the understanding of the many ways in which foraging people work with their environment. The book adds much to the work that has already been done in regard to indigenous management methods in the rest of the world, including prehistoric Europe. The title is intended to make the reader aware of the fact that Native Californians (and in truth pre-agricultural people everywhere) were not passive in their use of the environment but had strong and systematic interactions with it.

There is a problem, however, and it is comes from the fact that when the word "wilderness" is used here, it is meant in terms of the the recent, nonhistorical, legalistic, bureaucratic definition of "wilderness" developed in the mid-sixties. This definition, which became part of the language of the Wilderness Act, described a wilderness as a place without noticeable human impact or permanent presence. For the purposes of legislation, that was appropriate for the lower forty-eight,

but it required rethinking in the case of Alaska, and indeed was to some degree redefined. Subsistence hunters are allowed to carry guns and shoot caribou in the gates of the Arctic National Park. We should not let the legislative definition henceforth dominate our language.

One of the several historical usages of "wilderness" (in America as well as Europe) has always allowed that it was where the "savages" lived (*sauvage*, from *silva*, forest, people of the forest). Since it's a fact that humans have been active for millennia (Homo sapiens for at least fifty thousand years), we must inevitably factor the history of some human presence into what we call the "natural condition of the land." In other words the condition of wilderness, by proper definition, *includes* a history of inhabitory peoples and their uses and practices. The word is not thereby rendered meaningless, however, since it refers to landscapes that, even if used by foragers, remain over-whelmingly in the realm of wild process, and in which biodiversity is usually not significantly impacted.

There are also functional and psychological definitions of wilder-ness. In virtually every premodern society there has been a part of the territory that was its wildest place, the least-visited, the most mysterious; and that—on whatever scale—is the working wilderness of the society. When contemporary Native Americans say "we had no wilderness," they are speaking in terms of the recent bureaucratic use of the word. In truth they all had areas that were their "wildest spaces."

We should make some distinctions as to the four periods of human impact on nature: (1) pre-agricultural, (2) the agrarian world, (3) the historic industrial world, and (4) post–World War II, which Barry Commoner says has in many ways been the most devastating of all. During these recent decades we have seen totally new and unpredicted environmental impacts, as from radioactive waste and vast quantities of little-understood toxic chemicals. The "management" that might have taken place in pre-agricultural societies is minuscule compared to the environmental effects of agricultural and industrial societies.

"Wild" as process is universal. Wildernesses are places where those wild processes are at work in large proportion. Many ecosystems are deeply shaped by wildfire. In California, where so many fires are started

by lightning, it is hard to tell where native burning starts and wildfires leave off. In any case the forests of California were functioning with full biota and were basically wildernesses. Prior to agriculture the whole landscape, except perhaps for a few acres here and there intensely and regularly managed for something like redbud shoots or deer grass, could have been called wild.

So to say "California was not a wilderness prior to European occupation" is not exactly correct. To say that "indigenous people apparently managed a large proportion of the landscape" raises the question of just *what* proportion is being suggested. There was an estimated population of one to five million nonagricultural Californians living along coasts and rivers. The amount of landscape visibly altered by these societies that had no bulldozers was clearly infinitesimal. The impact of hunter-gatherers everywhere was so light that it would take a trained eye—the eye of a tracker or a trained horticulturalist or a forest ecologist—to even guess at it. I take this to be very much to their credit, and an impressive sign of their economic and environmental wisdom. The pre-agricultural world everywhere was, if you like, a *virtual* wilderness. It sponsored and maintained (with a few small exceptions) great biodiversity. Even in the late twentieth century there are still vast and pristine stretches of lower forty-eight land that we feel greatly inspired to be out in.

There is a cogent political point here: the resource-use people, the clever urbanophile postmodern sophists, extreme-end land-managers who think the whole of nature was made to be managed, theological fundamentalists, and the developers and politicians, are already seizing on the phrase "America was not a wilderness" and the idea that "Native Americans managed it," so that they can say, "See? It was never natural anyway. What are you complaining about? Let us go ahead and do our thing, too." It will take all the political will and intelligence we can muster to preserve basic biodiversity in the face of these forces. The right use of words, and standing by those words, are essential.

'94/'01

11.

Allen Ginsberg Crosses Over

■ ■ ■

MID-MARCH (1997) I heard from Bob Rosenthal, Allen's close friend, that Allen wasn't feeling well, and that he was in the hospital for a checkup. I called Bob, and he explained that Allen's diabetes, heart-murmur problems, and several different medications had coincided in such a way to make him extremely fatigued and disoriented. And then, when I called Allen at the hospital, he told me they had diagnosed him with a recurrence of hepatitis C from years ago in India or Mexico. He was so medicated that he wasn't able to talk very clearly.

22 March this year (about twenty days earlier than usual) was the perfect afternoon for *sakura*-viewing. A few friends came over, we heated saké, sat out on the *engawa*, and had some sashimi as well. The two thirteen-year-olds, Robin and David's daughter Micah, amused themselves bounding on the trampoline as we gazed through the fully opened thirty-year-old *yaezakura* into the sunset.

Sitting cross-legged and chatting on the board deck. The cordless phone trilled—Allen Ginsberg, in Beth-Israel Hospital, calling me back, this time wide awake, to chat. The phone went around to several old friends, as we viewed the flowers.

> Cherry blossoms falling
> Young girls rising
> Us on the deck.

Raw tuna, saké,
>> And blossoms.
>>> Spilled shoyu.

End of March I had a call from Allen late at night. He said that he had just been diagnosed with liver cancer, and the doctors said he had two to five months to live. He also told me at that time that his affairs were all in order, he had decided his will, and that things were—in that sense—in good shape. And that he would be going home to his own apartment in a few days, because there was nothing they could do for him in the hospital. I told him I would come to New York to visit him in a few weeks. It was a sweet conversation, which he closed with a "Good-bye—" that started gaily and ended with a little sob.

A few more days went by, and wondering if Allen was home yet I called again. Ginsberg historian Bill Morgan told me that Allen had come back, and then had a stroke the previous night, and was right now in a coma. He said Allen probably didn't have more than twenty-four hours to live. That was on the morning of Friday, April 4th. They said Allen's Tibetan teacher Gelek Rimpoche was flying in from Jewel Heart in Ann Arbor.

The next morning, 2:30 A.M. April 5th, Allen died, still in a coma.

A few days later I flew to Illinois to give a talk.

READING BASHÔ ON THE PLANE

Between lectures,
>> This little seat by the window
>>> My hermitage.

Got back home, had a call from Gelek, who told me of chanting and sitting with Allen before and after he died. "He had NO attachments. He was ready to GO," Rimpoche said.

—And this one came back to me, by Kyorai:

The day before yesterday
 Crossed the mountain over there—
In the full bloom of the cherries.

19.IV.97

12.

Highest and Driest

■ ■ for Philip Zenshin Whalen's Poetic Drama/Dharma ■ ■

I FIRST SAW PHILIP from the wings backstage. He was out front in a rehearsal, directing some point with the actors. His confidence and clarity impressed me, a freshman at seventeen, naive and new.

Philip as director and actor for some student production—I heard soon, though, that he wrote poetry, and then in conversation later, I was delighted by his erudition and searching wit. We became friends.

Philip had grown up in The Dalles—up the Columbia gorge and at the beginning of the dry side of the ranges. He had been in the Air Force and had already read much philosophy, literature, and history. Being part of Phil's circle was like being in an additional class—having an extra (intimately friendly) instructor, one with nutty humor and more frankly expressed opinions. He extended us into areas not much handled by the college classes of those days, such as Indian and Chinese philosophy. I had done some reading in the *Upanishads*, had ventured into the *Dao De Ching* and the Confucian Classics, and was just beginning to read Warren's translations from Pali Buddhist texts. Philip led the way in making conversation possible, and then making poetry, out of the territory of those readings. His own poetry circled around and into it a bit, with a dimension that was not quite present in our official modernist mentors Yeats, Pound, Eliot, Williams, and Stevens. (My other close new poet friend in this loose group was Lew Welch.) Philip had an elegant style of speaking with intonations, phrases, and subtle linguistic mannerisms that lightly affected many.

The Chinese-American World War II veteran Charles Leong,

brilliant student and expert calligrapher; plus Lloyd Reynolds, who taught printing, calligraphy, art, creative writing, William Blake's poetry, and much else—moved in and out of these conversations as well. In some odd way there was already a Pacific Rim postindustrial consciousness in the air then, right in the sleepy backward old Pacific Northwest where the restaurants were either Swedish smorgasbord or things like "The Oyster House." The memories of the I.W.W., the Industrial Workers of the World, were not totally dried up either; same with the memories of the big old-time logging camps and the extravagant earlier salmon runs.

I wasn't writing much poetry yet—but Lew and Phil were, and we all admired it. I didn't begin to write poems that I could relate to until I was in my mid-twenties. By that time I'd been briefly in Indiana for graduate school and then back to the Bay Area to live and work on the docks of San Francisco. Philip and I shared an apartment on Montgomery Street and began to move in cosmopolitan circles of writers and artists of the whole Bay Area: Robert Duncan, Jean Varda, Jack Spicer, Michael McClure, and many more. We got to know Alan Watts, met Claude Dalenberg and the McCorkle brothers, and attended the Berkeley Buddhist Church's Friday night Study Group meetings (Jodo Shin was our first contact with a living Buddhist practice).

Philip and I would go our separate ways to job opportunities here or there, up and down the whole West Coast, but we would always end up back in San Francisco at some convenient meeting place like Cafe Trieste or, a little later, Kenneth Rexroth's Friday evening salon. Chinese poetics, the flow of Indian Sanskrit poetry, Pound's line, Blake quoted by heart, Gertrude Stein avidly read aloud, Lew Welch singing Shakespeare songs to his own melodies, all led the way toward whatever it was we did next. Like taking up the study and practice of Mah Jong and the *I Ching*, or cross-town walks to the beach and the Legion of Honour. Philip was always writing, always reading, and whenever possible playing music. At one time he went to considerable trouble to get an old pump organ into our apartment to play Bach on.

Allen Ginsberg and Jack Kerouac came to town and catalyzed the energy already fully present into a more public poetics and politics. I left for my long residence in Japan. For some years I sent Philip the news of the Capital, until he came there. Once in Kyoto, Philip seemed instantly intimate with the sites of literature and history, commenting that "*Here* was where Lady Murasaki had that little altercation with the other lady over which carriage should go first," or some Buddhist temple that had been built on an old palace foundation. Then he began to be drawn more and more to the message of the big Buddhist temples, and the lessons of impermanence their vast graveyards out back provide: thousands of little stupas for the priests of the past. Thus moving from the seductive cultural fascinations of old Japan to a deeply realized *samsaric* awareness. Note well his poetry and prose from the Old Capital. Once back on the West Coast it was not long before he made the step into full Zen practice.

Once a priest, it was clear that this was Philip's true vocation. He had the dignity, the learning, the spiritual penetration, and the playfulness of an archetypal Man of the Cloth of any tradition, and yet was not in the least tempted by hierarchy or power. Philip never left his poetry, his wit, or his critical intelligence behind; his way of poetry is a main part of his teaching. His quirks became his pointers, and his frailties his teaching method. Philip was always the purest, the highest, the most dry, and oddly cosmic, of the Dharma-poets we've known—we are all greatly karmically lucky to have known him.

CLAWS / CAUSE

for Zenshin

"Graph" is graceful claw-curve,
 grammar a weaving carving

paw track, lizard-slither, tumble of
a single boulder down. Glacier scrapes across Montana,
 wave-lines on the beach.

Saying, "we were here"
 scat sign of time and place

language is shit, claw, or tongue

"tongue" with all its flickers
might be a word for

hot love, and fate.
A single kiss a tiny cause [claws]

—such grand effects [text].

13.

Afterword to a
New Edition of *Riprap*

■ ■ ■

I GREW UP with the poetry of twentieth-century coolness, its hard edges and resilient elitism. Ezra Pound introduced me to Chinese poetry, and I began to study classical Chinese. When it came to writing out of my own experience, most of modernism didn't fit, except for the steer toward Chinese and Japanese.

Although I had written a fair number of poems, by the time I was twenty-four I was ready to put poetry aside. My thinking had turned toward linguistics, the Whorfian hypothesis, North American oral literatures, and Buddhism. My employment skills were largely outdoors.

So in the summer of 1955 after a year of Oriental languages graduate school, I signed on with the Yosemite National Park as a trail crew laborer. They soon had me working in the upper reaches of the Piute Creek drainage, a land of smooth white granite and gnarly juniper and pine. It all carries the visible memory of the ice age. The bedrock is so brilliant that it shines back at the crystal night stars. In a curious mind of renunciation and long day's hard work with shovel, pick, dynamite, and boulder, my language relaxed into itself. I began to be able to meditate, nights, after work, and I found myself writing some poems that surprised me.

This collection registers those moments. It opens with a group of poems written around the transparency of mountains and work, and finishes with some that were written in Japan and at sea. The title *Riprap* celebrates the work of hands, the placing of rock, and my first

glimpse of the image of the whole universe as interconnected, inter-penetrating, mutually reflecting, and mutually embracing.

There is no doubt that my readings of Chinese poems, with their monosyllabic step-by-step placement, their crispness—and the clat-ter of mule hooves—all fed this style. I went from the Sierra Nevada to another semester's study at Berkeley and then a year's Zen study in Kyoto, and nine months in the engine room of a tanker in the Pacific and Persian Gulf.

On my second trip to Japan, with the help of Cid Corman and Lawrence Ferlinghetti, the first edition of *Riprap* (five hundred copies) was printed in a tiny shop a few streets away from the Daitoku-ji Zen Temple complex. It was folded and bound East Asian style.

The little book moved. After a second Japanese edition of one thou-sand was gone, Don Allen's Gray Fox Press picked it up and printed it in America. Don and I decided to add my translations of the T'ang era mountain Chan poet Han Shan. I had started these in a seminar at Berkeley with Chen Shih-hsiang. Chen was a friend and teacher. His knowledge and love of poetry and his taste for life were enormous. He quoted French poetry from memory and wrote virtually any Chinese poem of the T'ang or Sung canon from memory on the blackboard. Chen's translation of Lu Ji's *Wen Fu* "Prose-poem on Writing" gave me the angle on the "axe handle" proverb "When making an axe handle, the pattern is not far off," as it applies to poetry. (Mind is manifesting mind.)

I would have gone on to do more Chinese poetry translation had I stayed with the academy, but my feet led me toward the zendo.

The idea of a poetry of minimal surface texture, with its com-plexities hidden at the bottom of the pool, under the bank, a dark old lurking, no fancy flavor, is ancient. It is what is "haunting" in the best of Scottish-English ballads, and is at the heart of the Chinese *shi* (lyric) aesthetic. Du Fu said, "The ideas of a poet should be noble and simple." Zen says, "Unformed people delight in the gaudy, and in novelty. Cooked people delight in the ordinary."

There are poets who claim that their poems are made to show the world through the prism of language. Their project is worthy. There is

also the work of seeing the world *without* any prism of language, and to bring that seeing *into* language. The latter has been the direction of most Chinese and Japanese poetry.

In some of the riprap poems, then, I did try for surface simplicity set with unsettling depths. It's not the only sort of poem I do. There is a place for passion and gaudiness and promiscuous language. The plain poems that I launched in this book run the risk of invisibility. But the direction they point is perhaps my favorite, and what a marvelous risk!

The poems also made their way back to the Sierra Nevada, where trail crews still place sections of literal riprap. I gather the poems are appreciated as much for their sweat as their art. Veteran trail crew foreman (now historian) Jim Snyder told me how the collection is now read by firelight in work camps in the backcountry.

'90

14.

The Cottonwoods

■ ■ ■

THE ALAMO is across the lane from the Menger Hotel. The Menger Bar is the oldest bar in Texas—they once settled big cattle-drive deals here. This is the center of downtown, now, with tall buildings all around, but the Alamo is a kind of park in the midst of it all, with its old liveoaks, grass, sand, and cactus, and a few low stone and adobe buildings. I'm in the Menger bar, nursing a shot of rye, a Sunday evening in February, reviewing what I think I learned this weekend.

There is some fine underground water in this part of Texas. Pure gushing springs that break through the limestone substrate. The San Antonio River runs clean and fast, just up from underground. The wild pecan trees once flourished here. So the Payaya Indians had a lot of settlements around, and there is a deep archeology to it all. Alvar Nuñez walked through the area in the 1530s. Spain, without even knowing what was there, claimed this unknown northern space in 1519. Then the Spanish sent a scouting party here in 1691. The report was so good they started a mission—twenty years later—Mission de San Antonio de Valero, and the larger area got called Tejus. The local village was named Bexar after a Spanish nobleman. In 1731 the Spanish government underwrote the voyage of fifty people, fifteen families, from the Canary Islands to Bexar to help colonize it. They were granted the title of Hidalgo. The huge millstone they brought with them is there in the Alamo museum.

Altogether five missions were started along the San Antonio River.

Stone and adobework, weaving, agriculture—but in time they faltered. The Comanche and Apache, who had mastered the horse by then, came down out of the west and north and began to harass both the local Indians and the settlers. Illness swept through. Church policies changed. In 1793 the missions were withdrawn and the farming land divided up among the Indian converts and the Tejano settlers of Spanish descent who stayed.

Anglos began drifting in, looking for land. In 1803 the Spanish government sent up a cavalry detachment to protect the settlers. It had, from its original place of assignment, the nickname "Alamos"— Cottonwoods. The soldiers set up in the ruins of the old mission. It became a fort, known as "Alamo" after the cavalry unit that was based there. During the subsequent decade the Mexican revolution was under way, and Mexico won independence from Spain. Meanwhile Americanos kept coming in and settling; Stephen Austin led three hundred into Mexico in 1822. Mexico promised statehood to this growing new territory. General Antonio López de Santa Anna, who had fought against Spain, made himself dictator of Mexico and imposed taxes on Tejus. Feeling unrepresented and exploited, both Mexicano and Anglo settlers together issued a "Declaration of Causes" putting forth their complaints. Santa Anna sent General Cos north to punish them, and they had a little battle. Cos was killed and his small army defeated. Santa Anna was furious and headed north with an army of one thousand. One hundred seventy-two American newcomers, Tejus Anglo settlers, and Tejanos made a stand in the fort. It took Santa Anna six days to defeat them, and they all died in the struggle. Famous names included Jim Bowie and David Crockett. Six hundred of Santa Anna's army died. This was in 1836.

Ten days later Sam Houston's army caught up with Santa Anna and in the battle of Velasco defeated him. The treaty of Velasco guaranteed independent statehood to Tejus. Sam Houston was the first president. France, Great Britain, the United States, and other countries soon recognized it, but Mexico did not.

Ten years later Texas joined the Union. At the Treaty of Guadalupe Hidalgo, in 1848, Mexico agreed to the loss of Texas and California

both. Many former Mexicans were strong supporters of both inde-
pendent Tejus and then joining the United States. They were all over
the area by now.

The town is now called San Antonio, after the mission, but the
county is called Bexar after the original name of the village. The San
Antonio River, where it runs through town, has been directed and
manicured and is now called "Riverwalk" and is lined with shops and
restaurants. At night it is gala with Japanese lanterns and Mexican
music. It creates a world of cheerful saunterers along small bridges
and crosswalks, and outdoor café couples with their glasses chiming
to each other. It is one level below the streets, and sometimes rolls
on through arch-roofed tunnels under buildings, to come out again
into gardens. Quiet launches serve as buses carrying people up and
down the route, altogether two and a half miles long. Cars and trucks
pass overhead across bridges. A huge three-story mall abuts the old
Menger Hotel, with high skylights and gleaming tile floors. It is called
"Rivercenter."

A sharp young fellow from New York who had come out to Texas in
his twenties became Sam Houston's boldest and most effective scout.
He had very bad hearing, so his nickname was "Deaf" (pronounced
"deef"). In about 1820, in San Antonio, Deaf Smith had married "a
beautiful widow" who was a descendant of those Canary Islanders.

The Menger bar is all the original wood. Dark and gleaming
now—

 Deaf Smith. I remember that *wheat*
 back in the sixties drive out to the co-op for it
 "Deef Smith County whole wheat berries"

 and grind it ourselves.

15.

Harriet Callicotte's Stone in Kansas

■ ■ ■

WES JACKSON invited me to come to read some poems and give a talk at the Kansas Prairie Festival one year. This happens every year now at the Land Institute, the perennial ethnobotanical future agricultural research and teaching station that Wes and Dana founded. I asked Wes how far is Salina from Carneiro, Kansas, and he said not far at all.

"Carneiro" is a town from the telling of my mother's family's lore. Lois Snyder Hennessy, my mother, born Wilkey. Her mother was Lula Callicotte, born in Maryville, Missouri. Lula's mother, Harriet, died in childbirth in Carneiro in August of 1884. She was having twins, my mother says. She asked to be buried under a stone that one of her sons had played around, and had once traced the outline of his small hand in with a nail or knife. It was a solitary piece of sandstone in an isolated field on a hill outside of town.

In early June of 1985, my son, Gen Snyder, and I fly into Wichita and are driven to Salina. Two days of talks by handy farmers and agrarian intellectuals, a great presentation by Gene Logsdon, poems by Harley Elliott and Joe Paddock, and a play by Nancy Paddock. Beer kegs in the warm evening. Den Berry plays a fine guitar. Wes the impresario, the long view, the true scientist.

Kelly Kindscher has come up from Lawrence. He is a prime bioregional thinker, leader in the "Kaw River Watershed Council," scholar of agro-ecology and ethnobotany, the man who walked the width of

Kansas to feel the watershed in his very bones. Kelly says he'd like to help Gen and me look for Harriet's gravestone after the festival. A warm humid breeze blowing over the rolling grasslands. Far lookouts. This grassy growing smell. Salina's twelve-hundred-foot elevation.

A cool morning, with a cloud layer. The prairie festival is over. Kelly, Gen, and I drive west on modest two-lane grassy-shouldered Highway 140 through Bavaria and Brookville to Highway 141, the Carneiro turnoff. The grasslands and wheatfields of central Kansas, Ellsworth County. Carneiro is three-quarters a ghost town. There are a few occupied houses, but it is mostly vacant wooden buildings, vine- and brush-overgrown vacant structures. After cruising a bit through the small-town grid we double back from the railroad-tracks edge of settlement and again up the main street. A substantial two-story brick schoolbuilding, closed and broken. The inscribed date is 1915. We stop and peer into another large building through the window. "Open" it says, but there are padlocks on the door. It is full of recent castoffs, and outside along the wall are discarded stoves, washers, refrigerators.

Across the street a man is ambling about his well-tended mobile home. A collie trots toward us. We walk across the street to him. He asks "do you want to get into the store?"—I say "I'm looking for a rock" and explain my quest. "I'm new here" he says. "I never heard of anything like that." But he says Mr. Sneath across the street (now out) might know. He has a purple pitted nose. And then he recalls: "There *was* a place like that I heard about east of here. Go back toward Brookville about one mile past where 141 crosses the road (Kanapolis Lake and the state park) and turn right. About one half mile south the road takes a bend and you might find something there. You might stop and talk to Mr. Mullin."

We find our way down narrow gravel roads with fenced wheatfields or grazing on both sides. "Lots of Holstein bulls," Kelly comments. At the bend we stop, park, and go through the fence to beat the grass and look. Gen spots a hollow square of stones, most likely an old cabin foundation. It is a little corner left unmowed and uncultivated. But there is no single large stone. So we drive on around the mud-puddle road to the nearby farmhouse, pull into the driveway, and park by a

double garage. The light's on, and someone is working in there. A tall thin elderly man with blue eyes and white hair comes out. Again I tell the story "My great-grandmother lived in Carneiro, and my great-grandfather worked on the railroad. She was dying in childbirth, and she told her family that she wanted to be buried up on the hill outside of town near the old emigrant wagon road where there was a big stone with a child's hand engraved on it. So they buried her there and added her name to the rock. Later a little fence was put around it. My mother said that it was famous in town, and that anybody I asked could tell me where the gravestone was. My sister got somebody to take her there in the fifties. But so far I haven't been able to find anyone who knows of it." He says he's really sorry, but he has never heard of it. Just as we're about to leave he invites us to look at the work he's doing in the garage. On the bench at the back, tools and a vise, he is making stainless steel spurs. "So blamed hard, it's slow work—uses up a lot of drill bits." They are clean simple designs, and very good looking.

Then he asks us to see his spur collection in the house. We go in through a screen door and a wood door and are greeted by his wife. I ask her about the gravestone. She says "I *heard recently* of something like that. Who from? A stone grave-marker, I think. They said it was on the old Smith property." She gives Kelly instructions on how to find that piece of land. We then look at a case of fine crafted spurs, each stamped with a tiny ccm. "Charles Christopher Mullin, that's me" he says. "I sell them at fairs and at rodeos. It's my hobby."

We head west again, down dirt roads that take us past the Mushroom Rocks in Kanapolis State Park. We walk a bit through these odd formations of resistant rock above, softer rock that has been cut away below, leaving twelve-foot-high "toadstools." My mother had spoken of these rocks and had shown me an old color postcard of them. The road turns north and goes over a gentle grassy hill. To the west there is a windmill. This is as Mrs. Mullin had described. We get out and push into the grass, but it is such a vast hill, such wide grass range, that we soon doubt we can find anything. We see that the road we're on loops right back into Carneiro, so we drive back in and up to Mr. Sneath's house to see if he's home yet. His wife comes to the side-porch door.

Mr. Sneath, she says, is "Out working some cows." I tell her of our search. She says, "That land used to belong to Smith. I lived up there until about forty years ago. There was a stone with a name on it alright. I don't remember the name." She tells us where to find her husband, going back to the main paved road and then up a side road through some cottonwoods. Gen, Kelly, and I drive there, easing in and out of water holes. It has started showering rain. We negotiate a saggy barbed wire fence-gate held by a lever-tightener stick. We walk around a bend into a muddy corral where two men are standing by a pickup. They don't notice us until we're almost up to them.

He hears me out. "It's there alright. East of the windmill about two hundred yards on the highest ground." The younger man adds "Ola Shellhorn, in 'The Pines' retirement home in Ellsworth, would be the one to know most about it." We drive back again through Carneiro, cross the railroad tracks, and climb up the hill, which is a miles-long east–west running ridge about two hundred feet higher than the town site. We park off the side of the road and slide through the wire fence. Walking east, hundreds of yards, onward and onward, to the highest point on the ridge. I know we've come too far. All there is to see is grasses, this long ridge, and a shelterbelt of trees down the slope to the south. A good view north to the Carneiro basin. Longer views of far-off prairies rolling. The sun is near the edge, and the sky is darkening with more rain clouds and hints of further showers. We turn and start walking toward the car. Kelly notes a faint depression in the ground and a subtle change of vegetation within that. "A wagon road probably"—and he wonders if this might be the ghost of the old Fremont wagon trail, which tended to follow high ground. We walk this faint trace, which goes downslope and runs parallel to the spine of the ridge. I see some rock poking through the grass. Closer, it's reddish-tan, about two and a half feet wide, lying on its back. Then I am over it and can see the lettering, HARRIET CALLICOTTE, sure enough. Gen and Kelly catch up. Gen kneels down next to me, and we try to see if anything else is legible, but clearly the stone has been eroding away, and only these larger letters remain. No trace of the hand, or her dates.

No fence, only an irregular circle of smaller rock chunks around it. We stand and look around the sweep of the whole landscape, putting it in mind (as I did at Vulture Peak in Bihar the day I visited there, to remember it in future lives), and I tell Gen to remember the lay of the land so he can find it again someday. Specifically: it is up the hill south of Carneiro, about nine hundred feet east of the road, and about eighty feet north of the faint watershed divide of the ridge. I chant the *Heart of Great Wisdom Sutra*, the ceremony for the moments when realities roll out and up, like a seal or a whale surfacing, and then dive back again into the depths. I tell him "Now you've touched the far ends of your ancestry. You've been to the tomb of the Ibaru clan in Okinawa, and you've seen your great-great-grandmother's headstone in Kansas."

Lula Callicotte met Rob Wilkey when she was nineteen. They were going out on a date, riding in Rob's wagon to a party, when a storm came up and they lost their way. They crossed and re-crossed several creeks all night. By morning they had found their way to the town of Ellsworth. They went straight to a preacher and got married, and then told Lula's father. Rob and Lula later went west to Leadville, Colorado, where he worked in the mines. Eventually they moved to Texas to work for the railroad. My mother, Lois, told me how she had been brought to see this grave by her mother, Lula, on a visit from Texas when she was quite small. "She flung herself on the ground before her mother's grave and wept. Then she paid a man named Luck to carve her mother Harriet's name into it and put a fence around it. He sent her a photo of the fence to prove it had been done." I have seen that photo.

We walk back to the car in a slanting rain lit by the setting sun from under the edge of the clouds.

Kelly Kindscher has further rocks in mind: He drives us back on Route 140 to a place from which we walk a path along the edge of a wet field of ripe wheat for over a mile. We push through small brush, cross a creek, go by a field of young alfalfa and thru a sumac (Kelly pronounces it "shumac") stand, around a hillside, and find ourselves under a cave on the side of a rocky hill. Soft sandstone. There are the names of

Euro-Americans of the last century scratched here and there, and higher up and deeper in the elder petroglyphs. One impressive glyph on the rock face above the cave mouth is about twenty feet long. Information traveling on rocks through time.

And heavy rain, really wet now. We return to the car with squishing shoes. Rain-heavy heads of wheat, singing meadowlarks, June evening rainclouds. Gen strangely good-humored in the wet. We drive back through Brookville to Salina for a celebratory Mexican dinner—the three of us—and then Gen and I meet Wes Jackson, who drives us through the night with talks and plans (and the many mysterious lights that appear in the dark on the Kansas plains) to Wichita. We catch our late night plane back to the western coast.

16.
Empty Shells

■ ■ ■

I'M NO stranger to chickens. As children on the farm north of Seattle, my sister and I helped tend Guernsey milk cows and had responsibility for the Rhode Island Red layer flock entirely to ourselves. We had a tidy little egg business with the neighbors that eventually earned us our own bikes. We were serious at reading the Government Poultry Bulletins on matters of feed and ailments, and kept our henhouse clean, with a free-run fenced yard outside. That was in the days when almost every rural household had a hen flock, and many, like us, kept a couple of cows. The evolution of the Petaluma large-scale poultry industry changed all that with an emergent economy of scale that led to thousand-hen chicken-coops, the development of giant incubators, and finally a national market.

There's an estuary, *estero*, that sluggishly winds south from the hills and valleys north of San Francisco Bay and cuts in through the salt marshes. It is—was—navigable to a degree, and but an eye-blink back (in natural time) there was a Coast Miwok village upstream a few miles, called Petaluma.

This was a gentle landscape of oak grasslands, chaparral, and, westward toward the coast, occasional redwood stands. It was an unlikely stage for the nineteenth- and twentieth-century unfolding of a huge, enthusiastic, inventive, hype-filled egg economy, and the Egg Day Pageants.

Foreword to *Empty Shells: The Story of Petaluma, America's Chicken City*, by Thea Lowry (Manifold Press, 2000).

I moved to the Bay Area in the early fifties. The poet and all-around critic Kenneth Rexroth was a cutting-edge cultural leader of the radical intelligentsia those days, full of anecdotes and opinions. It was from him that I first heard of the "Yiddish-speaking Anarchist Chicken Farmers of Petaluma"—which at the time seemed like one of the least credible of Kenneth's many tales. I paid it little heed.

Later our father moved from Corte Madera to Petaluma and bought and renovated an old house there, and I started riding my motorcycle up from San Francisco weekends to hang out with him. Right away (this was the sixties) you would see the long silvery sheds on the land—like every meadow, back of every farmhouse—that were, I learned, the recently abandoned henhouses, the empty shells, of the dying egg industry. The egg part of Kenneth's story was true! And so, it turns out, was the Yiddish-speaking part (as this fascinating book tells), though it's not so clear how many genuine anarchists there were. The majority of egg farmers weren't Jewish, but those who were constituted a significant number in an already cosmopolitan population. The anthropologist Stanley Diamond once told me how as a young man he had gone to Israel to work on a kibbutz that raised chickens in quantity. He said the teachers and founders had come from Petaluma. "Getting the fryers out of there in the night, flapping and cackling, raising dust, four birds in each hand, by the feet. I hated it."

I've lived the last thirty years in the Sierra foothills, not far from where hydraulic gold-mining was responsible for washing hundreds of millions of tons of detritus into the watershed of the Yuba River. I kept a layer flock again during the seventies and got to see accipiters, coyotes, raccoons, and bobcats, thanks to them. The discovery of gold brought a sudden population to San Francisco, and Lowry tells us how that led to the near-destruction of the seabird nesting populations on the offshore Farallone Islands in order to supply eggs to the city, and how in turn an egg industry got going in Petaluma by the 1870s. The ramifications of the gold rush reached everywhere. Maybe Petaluma saved the local murres from near-extinction by taking them out of the wild egg trade.

Chickens were wild once—halfway still are—all going back to

Southeast Asian jungle fowl, who doubtless started to mooch around the Neolithic villages. They are lovely family companions, Chanticleer, Henny Penny, the Little Red (but in Petaluma, always White) Hen—the courage of roosters—the steady zazen of broody hens—Chicken Little; chickens have been as much with us over the millennia as dogs. Like milk cows, like the little white lamb, they are now part of an assembly line owned by remote corporations and worked by people at minimum wage. Petaluma was not able to make the transition to that much huger scale.

Lowry's book tells of some great American characters too, charismatic hen-cullers, genius chick-sexers (a skill that first came from China), shameless promoters of the Egg Days, the giant egg basket on parade, the Egg Queen in her yolk-yellow dress covered with feathers—the pre–World War II small-town American totally un-hip hype, and sort of high-school foolishness—some nostalgia I suppose for that; a crew in the parade called the "Clucks Clucks Clan"—but I'm telling too much.

Thea Lowry happens to be the sister with whom I shared a childhood egg business. Her persistence is prodigious. *Empty Shells* is a rich mine of information on a local West Coast poultry economy's rise and fall. Its interconnections reach west and far east. It is a deeply researched archetypal California Boom Economy and Optimism tale: ironic, silly, sad, and instructive. And we're all still riding on the same train.

17.

Grown in America

■ ■ ■

F ROM THE WEST COAST of North America it's about the same
distance either to Europe or to the coast of Asia. But coming
from Asia is easier—one simple boat trip straight across. No
wonder Chinese and Japanese people started coming here early, espe-
cially since they were needed; there was work. California's summer-dry
Mediterranean climate was the reverse of East Asia, which has wet
monsoon-type summers and dry winters. These newcomers brought
skills, will, focus, and a cooperative work style. It was soon clear that
they were going to be more than casual laborers. The Japanese, in
particular, came as families and headed for the farmland. With a com-
bination of research and dedication they learned the techniques for
farming in the new climate with glorious success—and openly and
honestly began to make themselves at home. The dominant society
proved to be more unpredictable and intractable than the land. In spite
of setbacks—stories we all know—the Japanese American people of
California have won a place they can be immensely proud of. They are
major creative contributors to our emergent North American/Pacific
Basin society. Part of the contribution they have made is "family." For
them, family has been a means of production, cooperation, contribu-
tion, and survival; and it has been a sublimely important end-in-itself.
Family always is, whether we know it or not, essential to who we human

Foreword to *Homegrown: Thirteen Brothers and Sisters, a Century in America*, by Carole
Koda (privately published).

beings are. Our Asian-American Americans coming from East to this uprooted Far West have provided a wonderful model of right living.

So this is a book of a particular family, a family to which I personally have a thin but fishing-leader-strong thread of connection, one which has taught and nourished me considerably. My wife, Carole, brought this book together. It has been great to be near her as she worked on it, watching her comings and goings, musings and transcribings. The "family" became part of our little family's daily life, as she made this work almost her life.

Over the last ten years, I've been to family gatherings and managed to meet many of the people who tell their stories here, and have learned their goodness as well as their stories; have witnessed some of the marriages and deaths that are inevitable in time. I feel honored to have been in a tiny way part of the process. So I want to commend this work not just to the present generation of the families involved, but to those yet to come, yet unborn, who will by virtue of this book get a better understanding of what it means to be a human being.

The world is made of stories. Good stories are hard to come by, and a good story that you can honestly call your own is an incredible gift. These stories are part of a bigger story that connects us all.

Carole Lynn Koda

OCTOBER 3, 1947–JUNE 29, 2006

gone, gone, gone beyond,
gone beyond beyond

bodhi

svāhā

Acknowledgments

THANKS TO

Language—
David Robertson, Ronald Grimes, Bei Dao, Kim Stanley Robinson, Jim Harrison, Clayton Eshleman, Drummond Hadley, Andrew Schelling, Jack Hicks, Robert Hass.

Land—
Doug Tompkins, Deane Swickard, Giuseppe Moretti, Kris Tompkins.

Thinking Fire and Forests—
Fred Swanson, Steve Eubanks, Tim Feller, Robert Erickson, Liese Greensfelder, Tony Clarabut, and the late Michael Killigrew. Skoverski Logging. Jerry Tecklin, who hosted a prescribed burn right in his front yard. And especially, Dr. Jerry Franklin.

Europe—
Olivier Delbard, Jean Clottes, Robert Begouen, Paul Kahn. The owners and staff of the Hotel Cro-Magnon in Les Eyzies.

Japan—
Kyoko Edo and the Arion-Edo Foundation. Yozo Sato, director of the Ehime Culture Foundation, and Scientist-Professor-Poet Dr. Akito Arima. Bruce Bailey, Professor Katsunori Yamazato, and Kazuhiro Yamaji, with his "Flying Books" in Shibuya. Tetsuo Nagasawa, commercial fisherman and poet of Suwano-se, Professor Shigeyoshi Hara,

Ken Rodgers and *Kyoto Journal*. Amita Nagasawa. Nanao Sakaki, Satoru Mishima, Morio Takizawa.

South Korea—
Ko Un, Professor Sangwha Lee, Professor Seong-Kon Kim, Professor Uchang Kim, and the organizing committee of the Daesan Foundation's Seoul International Forum in Literature. The deeply thoughtful Professor Nak-chung Paik. Hyung-kun Kim, of Eastland Press, irrepressible Dharma pilgrim. Kenzaburo Oe, for insights in the bus south of the DMZ.

& Really Close In—
Jann Garitty, for many years now. Gen Snyder, Kai Snyder, K. J. Steffensen-Koda, Mika Reynolds, and above all, Carole Lynn Koda.

Publications Record

The author wishes to thank those who have previously published sections of this work.

PART ONE

"The Ark of the Sierra": *Tree Rings* 10 (Spring 1997)

"Migration/Immigration: Wandering South and North, Erasing Borders, Coming to Live on Turtle Island": *Michigan Quarterly Review* 40: 1 (Winter 2001). Also published as "Erasing Borders: Human Flow on Turtle Island" in *Whole Earth* Summer 2002.

"Ecology, Literature, and the New World Disorder": *Interdisciplinary Studies in Literature and the Environment (Isle)* 11: 1 (Winter 2004). Also in *Irish Pages* Autumn/Winter 2004 ("The Earth Issue")

"Thinking Toward the Thousand-year Forest Plan," published as "Thinking Toward Another Thousand Years": *Tree Rings* 15 (Summer 2002). *Tree Rings* is the newsletter of the Yuba Watershed Institute.

"The Path to Matsuyama": *Modern Haiku* 36: 2 (Summer 2005)

"Writers and the War Against Nature": *Kyoto Journal* 62 (Winter 2006)

"Entering the Fiftieth Millenium": *The Gary Snyder Reader* (Counterpoint, 1999)

"Lifetimes with Fire": forthcoming in *Wildfire* (Deep Ecology Foundation, 2006)

Part Two

"Sustainability Means Winning Hearts and Minds": *Tree Rings* 17 (Winter 2005)

"Can Poetry Change the World?": *Caffeine Destiny* (online zine), interview with Susan Denning, 2001

"Three Way Tavern": foreword to *The Three Way Tavern*, by Ko Un (University of California Press, 2006)

"The Will of Wild Wild Women": foreword to *The Japanese Psyche: Major Motifs in the Fairy Tales of Japan*, by Hayao Kawai (Spring Press, 1996)

"Coyote Makes Things Hard": foreword to *The Maidu Indian Myths and Stories of Hánc'ibyjim*, by William Shipley (Heyday, 1991)

"Shell Game": foreword to *Shell Game: A True Account of Beads and Money in North America*, by Jerry Martien (Mercury House, 1996)

"The Way of Poisons": foreword to *Pharmakopoeia*, by Dale Pendell (Mercury House, 1995)

"On the Problems Lurking in the Phrase 'Before the Wilderness,'" published as "A Note on Before Wilderness": *Tree Rings* 8 (October 1995)

"Allen Ginsberg Crosses Over": *Sunflowers and Locomotives*, ed. David Cope (Nada Press, 1997)

"Highest and Driest": *Shambhala Sun* (November 2002)

"Afterword to a New Edition of *Riprap*": *Riprap and Cold Mountain Poems* (Shoemaker & Hoard, 2004)

"The Cottonwoods": *Terra Nova* 3: 4 (Fall 1998)

"Empty Shells": foreword to *Empty Shells: The Story of Petaluma, America's Chicken City*, by Thea Lowry (Manifold Press, 2000)

"Grown in America": foreword to *Homegrown: Thirteen Brothers and Sisters, a Century in America*, by Carole Koda (privately published, 1996)